SWORD AND BRUSH

SWORD AND BRUSH

THE SPIRIT OF THE MARTIAL ARTS

Dave Lowry

SHAMBHALA
Boston & London
1995

Shambhala Publications, Inc.
Horticultural Hall
300 Massachusetts Avenue
Boston, Massachusetts 02115

9 8 7 6 5 4 3 2 1

First Edition

Printed in the United States of America on acid-free paper ♾
Distributed in the United States by Random House, Inc.,
and in Canada by Random House of Canada Ltd

Library of Congress Cataloging-in-Publication Data
Lowry, Dave.
 Sword and brush: the spirit of the martial arts/Dave Lowry.
 p. cm.
 ISBN 1-57062-112-8
 1. Martial arts—Japan—Philosophy. 2. Calligraphy, Japanese.
 I. Title.
 GV1100.77.A2L68 1995 95-5653
 796.8'0952—dc20 CIP

To Pat Lineberger, *sempai*

CONTENTS

FOREWORD

During the 1980s a fortuitous sequence of events occurred. *Primus:* I found a book that described Japanese swordwork as I, an *aikidoka,* understood it. *Secundus:* I needed some information about Tesshu Yamaoka, the nineteenth-century sword genius. *Tertius:* I wrote to the author of the book on swordsmanship for clues on tracking Tesshu. *Quartus:* he wrote back. Thus I made the epistolary acquaintance of Dave Lowry, one of this world's more fascinating human beings.

Dave is a unique young man: a Yagyu Shinkage swordsman; a spiritual descendant of Cotton Mather; a *karateka* who writes about karate in popular magazines (and has the least popular opinions possible); a historian; an aikido practitioner who realizes the self-contradictory behavior of many leading aikidoka; an expert on gravestones; a student of the very rough and tough Shindo Muso ryu staff fighting; a medical writer; a cultured gentleman who speaks old-fashioned Japanese; a passionate Puritan; an ethnologist; a reasonably capable theologian; a weapons expert; a devoted family man; a lover of bird-watching, good wines, Japan, and New England who pursues his literary life in Missouri; a controversial scribe who can seem opinionated and arrogant but who is at center a man of deepest humility—who might well object vociferously to my describing him as humble.

In almost four decades in martial arts and Ways, I have never been so stimulated by anyone's writings as I have by Dave Lowry's. His letters are works of unself-conscious art, born from years of sweat in many a *dojo.* Not a dilettante littering the world with worthless notions, he is a true scholar of *budo* well worth hearing.

And seeing. As the brushwork in this book testifies, Dave is a consummate artist with the brush as well as with the sword and the word. Although I have been playing with *sumi-e* for thirty years, seeing Dave's work is very good for my humility.

I am honored to be able to commend to you this important contribution to our understanding of budo and of Japanese culture. In it we can see the truth of the maxim, *Ken fude ittai,* "the sword and the brush are one entity."

THE REVEREND CANON DOUGLAS SKOYLES
Church of Saint John the Evangelist,
Calgary, Alberta

ACKNOWLEDGMENTS

My sincerest thanks to all my *dohai* and seniors who have shared their insights on the Way: Messrs. Muromoto, Amdur, Bieri, Skoyles, Cieslik, Bates, Pittman, and Mesdames Usuda and Iida.

My gratitude to Ellis Amdur for reading the manuscript.

Thanks, too, to Swoboda and his staff at Wash. U., for their assistance and companionship, and to Jan, for lugging all that paper around. Finally, to my *kanai* and to my boy, who tolerated an ink-splattered summer.

DAVE LOWRY
St. Louis
July, Tanabata, 1994

SWORD AND BRUSH

INTRODUCTION

"The stroke is executed by cutting back, then down," is the teaching given in an ancient scroll, "followed by a swift, slight rise to the right like the movement of striking with a whip."

Another scroll, almost equally antique, contains poetic, if enigmatic, advice about the practitioner's state of mind, likening it to "a flower scattering, falling without sound on moss, a flower scattering to be heard through the depths of mountains."

Only those unacquainted with the paradoxes of art in Japanese culture would be surprised to learn that the first commentary is concerned with the gentle skills of calligraphy, the second devoted to the perfection of warriorship with the sword. At the core, the particulars of instruction, the matters of detail in effectuation contained in these old scrolls, are secondary to learning either art. It is the underlying principles that are of utmost concern, and these principles, in a broad range of Japanese arts—fine, folk, performing, and martial—are fundamentally synonymous. These principles are crucial to the mastery of any and all.

The actor in the Noh drama strives to make his way across the stage without a gap in his concentration, without a single superfluous movement. There is a sense of awareness of self and place surrounding the Noh actor that is understood perfectly by the warrior in the perilous arena where he performs. The *shakuhachi* flutist plays his instrument from his body center and perfects his breathing. The swordsman strikes from his center and the efficacy of his blow is assured by a proper attention to his own respiration. The goals differ, the attitude is identical.

It is not only in technical aspects that the varied endeavors of the traditional Japanese arts converge. From flower arranging to tea ceremony to archery, the aesthetics, the spirituality, and the motivations of these apparently disparate arts have a marvelous commonality. The unity of these artistic forces is exemplified in two disciplines, seemingly discrete, both at the very heart of Japan: the Way of the sword and the Way of the brush.

A Background

The appearance of the blade predates that of the writing implement in prehistoric Japan (a commentary on the evolution of our species, for where has it not?). Unearthed from tumuli built around the fourth century CE are short, double-edged swords based obviously on Chinese prototypes. We know almost nothing of the methods with which these weapons, and those that followed for the next four or five centuries, were used. No instruction in their implementation on the battlefield has survived. Yet by the eighth century, the beginnings of the elegant Heian Period, a distinctly native Japanese sword had evolved that appears to have been fearsomely effective. Its long handle indicates a two-handed grip. From its overall length we can infer that it was often swung from horseback. Its curve hints that, unlike older versions, the Heian sword was a weapon more for cutting than for thrusting.

Concurrent with the refinement of the sword was the rise of the warrior class, the *samurai,* or *bushi*. The bushi originated in the hinterlands of Japan, familial clans gathered around provincial lords, whose power was descended from primitive chieftainships. As the word indicates, the samurai were "retainers." Loyal servants, they were officials of local, completely self-contained governments of individual fiefdoms.

By the end of the tenth century these lords, or *daimyo,* had

assembled sufficient fortune, ambition, and means to begin casting covetous eyes toward the possessions of their neighbors. The fortunes were provided by taxation of farmers under their domain. The ambition stemmed from the growing wealth and influence of the daimyo class and from their desire to seize as much as possible before the intervention of imperial troops from the capital cities of Nara and Kyoto would make such lawless conquests more risky. And the means? It was supplied, of course, by the samurai. Already instilled with the frontiersman's proclivity for arms and action (and most of rural Japan was frontier in those days), the samurai took up the sword. In the furtherance of his lord's interests and desires, he became a professional warrior.

Two clans quickly emerged as leading contenders in this grab for feudal land and power. By the twelfth century, the Taira clan ruled much of the eastern plains of central Japan, and the Minamoto family controlled the west. Both clans were descended from branches of imperial aristocracy, a lineage not inconsequential in understanding the history of the samurai. Taira and Minamoto retainers were formidable fighters. Neither was the least hesitant to splash in blood to advance their lords' designs. But the noble blood of both clans provided in inheritance a regard for learning and the arts. The luminaries of these great families composed poetry and painted—they appreciated beauty eloquently. The Minamoto and Taira well deserved their most common appellation: *bushi* means "the martial elite" or "the martial paragon." They *were* an elite, not only in a martial sense but as a class, and they left for their successive generations a worthy example that guided the warrior in Japan for the following eight hundred years.

In a series of epic battles in the twelfth century, the Minamoto defeated the Taira, though it did not entirely destroy them as a family or a political force. Taira bushi escaped, cheat-

ing the Minamoto of what was to become an elusive dream for many a warlord for many a decade to follow: to dominate as a military power sufficiently to wrest governmental control over all Japan. In the five centuries after the Taira and the Minamoto, two other tigers came forward in turn and nearly succeeded. The ruthless Oda Nobunaga plotted and murdered against rival lords and was himself finally killed by a traitor in his own ranks. Toyotomi Hideyoshi was an even more cunning strategist, yet he, too, died short of unifying the country.

The legacy of the Taira and Minamoto and of Nobunaga and Hideyoshi was a heartbreakingly long period of civil war. Unlike the American and English versions, there were not two sides to Japan's civil conflict; rather, there were dozens, with daimyo forming alliances and ignoring them with deadly impunity. And instead of four years or even one hundred, Japan's internecine war lasted close to four centuries. In such an environment, the crafts of combat are apt to become very good very fast. In Japan, under the careful nurturing of the warrior class, they did. The lance, the bow, the halberd—the bushi wielded all these and other weapons, though always at the center of his armament was his sword. It was a weapon that perfectly embodied his ethos and spirit. It demanded the bravery of close engagement. It required skill not possessed by other classes. And in the capable hands of the bushi, the sword separated life from death in a single, utterly committed stroke.

Martial disciplines flourished during the Sengoku Jidai, the Period of Warring States, and so, too, the samurai's artistic avocations thrived. Tea ceremony, flower arrangement, poetry, and painting: these and other arts came to a state of excellence under the patronage of wealthy daimyo.

The bushi's predilections for these activities, apparently incongruous with being a fighting man, had more than one motivation. There was, first of all, his aristocratic breeding. To be

competent in the creation and the experience of art was expected of him, as much a part of his station in life as accomplishment in battle. A second reason had to do with the unique demands of the warrior's profession. For the samurai, encounters with art served both as a means of distracting him from the specter of death that accompanied him at every moment and as a forum allowing him to focus more pointedly on that death.

In 1600, one more leader made his bid for the domination of Japan. Tokugawa Ieyasu learned from the successes and mistakes of his predecessors. His alliances were sagacious; his retaliation against those challenging him was swift and final. In that first year of the seventeenth century, what was in Japan the fourth year of Keicho, Ieyasu managed to convene his major confederates and his antagonists on a broad plain east of Kyoto, called Sekigahara after a nearby village. At the end of the day, 21 October 1600, rows of the heads of Ieyasu's enemies lined the road all the way back to Kyoto as a testament to his victory.

Ieyasu realized the dream of the daimyo. He brought virtually all Japan under his hand. He and his successors became the Tokugawa *shogun,* who ruled the nation nearly until the twentieth century. The Tokugawa regime governed severely, but the peace it brought heralded a period of domestic prosperity and continued refinement of the arts. Ever the wise leader, Ieyasu knew that tranquillity also posed a new threat to his order. The land he united was one suddenly possessing an excess population of men who were competent in making a living only with a sword in hand. Place a stone in a pond, Ieyasu undertstood, and the fish within will strengthen themselves swimming around it. Deprived of the rock of warfare that they had been swimming against for generations, how long before the bushi became an idle burden to the country? Or worse, how long until they began to stir their own internal rebellion?

The Tokugawa shogun countered this threat by tacitly indulging personal duels among the samurai and challenge matches between their various schools of martial art, and so the warrior kept employed his precious sword. Equally important to his plans, Ieyasu encouraged the bushi toward a further pursuit of their artistic inclinations. He succeeded in this so well that no inventory of any of the arts of Japan would be even remotely complete without several examples contributed by these warrior aesthetes of the *pax* Tokugawa.

Modern Japan began in 1867, when the country was revolutionized through the opening of commerce with the West and by the abolishment of its feudal structure. Disbanded by official fiat along with all other classes, the bushi lost any practical need for his warriorship. He was proscribed by law from even wearing his sword in public. It is one thing to abolish a class and to prohibit its central symbol; it is quite another matter to eradicate the moral and social climate of that class and to dismantle the power of its symbol. The spirit of the bushi's sword has cut a deep pattern into the fabric of Japan's past. If one knows how to look for it, it remains visible almost everywhere in Japan today. It is found in the martial arts and Ways, of course—both the original classical fighting arts that have survived as well as the more common modern forms, such as judo, kendo, and aikido. But the sword and its attendant cult are also found within the social interactions in Japanese society and in its international relationships with other countries. Look for the heritage of the bushi, and much of Japan is revealed. If there is any doubt of this, one need only to watch a gaggle of Japanese grade-schoolers winding their way down any street, each one jaunty in a cap of red or white—the colors, it is no coincidence, that identified the clans of the Taira and Minamoto.

The artistic energies of the bushi have survived, too, so

healthily that they have been exported. Japan's arts, cultivated and informed in large part by the feudal warrior, have come to be known throughout the world. Exponents of the tea ceremony, *bonsai, ikebana,* and other uniquely Japanese arts are carrying them many thousands of miles from their homeland, where they reverberate significantly in the lives and cultures of countless non-Japanese.

One Japanese art that has captured the imagination of the West is *shodo,* the Way of calligraphy. To recount the history of this remarkable art requires an examination of the past that goes back further than to the origins of the Japanese martial arts, back further than even Japan itself.

The roots of pictographic writing are the beginnings of recorded history. They start at that moment when symbols—elemental representations of sun, moon, man, trees, and the like—were carved onto some suitable surface. In China, this occurred about the twenty-eighth century BCE. By most accounts, the medium was a smooth face of an animal's scapular bone. Notably, the genesis of this writing form was spiritual. The bones served as oracles employed by priests to divine the future. The writing itself was entirely pictographic in nature. Because the symbols were inscribed with sharp instruments, they were angular in form, all straight lines. Because they were the creation of many individuals in different places in China, there was at the beginning no consensus on their meaning.

By the third century BCE, the Chin dynasty, China's rulers acknowledged that oracular calligraphic carvings had entered the secular realm. They were used for bookkeeping in trade and, increasingly, as a literary form to write poetry and stories. Most importantly, from the Chinese emperor's perspective, the pictographs were used to record the accomplishments of the governing imperial court. Standardization was an impera-

tive, and the task fell to a prime minister and scholar named Li Ssu. Li Ssu developed a form of script based upon squares of uniform size into which all written characters would fit and eight basic lines from which all characters could be written. He was also instrumental in standardizing the rules of character composition (horizontal lines in a character are drawn first, then vertical ones; the character is composed from left to right and from top to bottom, etc.). Li Ssu's contributions to calligraphy rank among the epochal achievements in the history of communications. But no sooner was the task completed than it was in many ways outmoded. The obsolescence of Li Ssu's script came about because of two simultaneous events: the popularization of the teachings of Confucius and the appearance of the *four treasures*.

In response to the cruel imperial dynasties that had governed in the past, Confucianism, which promulgated a benevolently feudal rule of scholars and sages, attracted an enormous following. The thoughts of Confucius were eagerly devoured by the masses. The demand for them necessitated a production of written materials on a wide scale. Meeting that need were four objects that would change Asian civilization at least as significantly as would the philosophy of Confucius. The first was paper, made of the tender core of mulberry bark; second was ink, prepared from soot and animal glues; third was inkstones of slate or some other smooth, hard stone; and last was the brush.

The ink-wetted brush creates a line entirely different from that etched by a sharp stylus. It is easier to control when pulled down the paper than it is when pushed up. It is conducive to the drawing of curves rather than straight lines and careful angles. And in a talented hand, the brush can produce all manner of strokes, dots, and lines of a variety of thicknesses. The

brush drew a bridge between art and writing, and once it was crossed, brush-and-ink calligraphy flourished in China.

Not only was the philosophy of Confucius propagated among China's population with the brush, literature of every kind became available because of it. The calligraphy of the brush retained the block form of Li Ssu and his eight strokes, but writing itself was transformed. The calligrapher was free to experiment with his brush to create characters that emphasized balance and eye-pleasing form. The way a character was written imparted a message of style as well as its literal meaning. Style in calligraphy came to reveal much of the calligrapher's individual taste, education, and social background.

This form of calligraphy, along with the four treasures to write it, was introduced to Japan about 600 CE. Once again, the impetus was spiritual. Buddhism, another Chinese import, had spread throughout Japan, and Japanese priests needed to read and write about the new religion. As it had been in China, calligraphy in Japan soon expanded to other areas of communication. It was popularized by masters of the writing art, such as Emperor Saga and the brilliant priest Kukai, both of the eighth century. Also during that period the calligraphic *kana* syllabary was devised (almost entirely by noblewomen) to deal with the phonetical elements of the Japanese language that could not be written in borrowed Chinese characters. The *Man'yoshu* (Collection of Myriad Leaves), an epic volume of poetry and the *Genji monogatari* (The Tale of Genji), the world's first novel, were both written in kana script.

As the Chinese had before them, Japanese calligraphers sought to cross the span linking art and writing, and they went about it in similar ways. The basic characters, called *kanji* in Japanese, were composed of combinations of the same eight strokes of Li Ssu. As well, the kanji were fitted into the rectangles Li Ssu laid out centuries before. When softened and writ-

ten in a more cursive hand, the strokes became a more elegant and artistic way to write, a method called *gyosho,* a "traveling," or semicursive, script. The *sosho* style ("rough" or "rustic"), often known as the "grass" style, is a further abstraction of the kanji. Formal, semiformal, abstract—these three variations on basic brushmanship allowed vast artistic freedom for the calligrapher. From the tenth century on, the art of *écriture* bloomed and matured in Japan. Not a generation after that would pass that did not produce masters and masterpieces of the brush.

From the feudal period to modern times, the creative energies behind calligraphy in Japan were and are marvelous and endlessly dynamic. Kanji were brushed or carved on wood or chiseled into stone. Brushes were made from the hairs of a variety of animals and from soft twigs, reeds, and other natural fibers, all of which produced different kinds of strokes. Brushes the size of mops painted gigantic written works. Infants' hair was bound for brushes. One calligrapher insisted on using a brush of mouse whiskers; another was inspired to dip his long beard into an inkpot and write with it. Calligraphers played with puns inherent in written and spoken Japanese and with the pictographic nature of kanji to create works that are both delightful pieces of art and readable forms of communication. Writer, poet, artist—calligraphy combined the skills of all three in what gradually came to be known as shodo, the Way of Calligraphy.

In addition to the artistic impulses that attended it, calligraphy has been influenced by the philosophy of Zen. Conversely, the art of writing with brush and ink is a common metaphor for Zen thought. Once the brush has touched paper, the ink cannot be retrieved. It cannot even be brushed over, for to try to cover a mistake in this clumsy way is instantly obvious in the finished product. The calligrapher must concentrate and then throw himself completely into the execution of the kanji. Any

faltering, any self-consciousness will show up in his work. The calligrapher has one chance to create with his brush on a particular sheet of paper. The paper is a life before him, with a single opportunity to be lived and therefore to be lived fully and meaningfully. The brush writes a statement of artisanship that is as well a demonstration of personal character.

Interrelated with shodo's link with Zen was the consideration of the art of writing as a metaphorical battleground. The great Chinese calligrapher of the third century CE Wang Hsi-chin wrote extensively in this mode to explain the art. He compared the calligrapher's blank paper to the field of battle, the brush to a sword, ink to armor, and the inkstone to a river allowing strategic movement. For Wang and others, the skill of the calligrapher was the army's general, and the characters he planned to compose were tactics. The inspiration that seized him during the mechanics of brushwork represented fate, which decides ultimately the success or failure of the enterprise.

Understandably, the warrior of medieval Japan was attracted to an art explicable in these martial terms. It was clear to him that the spirit of calligraphy was perfectly compatible with that of war. The bushi used calligraphy as he did the other arts: as a method for simultaneously centering and balancing his mind and body. It served him, too, as a way of expressing his thoughts and emotions. Poems written by the samurai in his strong, bold calligraphy have the power to stir even today viewers who have never held a sword or known mortal danger. Centuries after they were brushed before battle, suicide, or any other time death threatened, the calligraphic statements of the samurai are still incredibly moving. Often written in a wispy, airy hand, one can sense that the authors of these statements have already stepped into a twilight realm between the living and the dead.

The Way of the sword, the Way of the brush: one an encounter of harmony between brush and paper, the other a meeting of conflict between swords. The results of each are inevitable and immutable. For the calligrapher as for the warrior, reality is reduced to a single unique encounter of perfect clarity.

A RATIONALE

To penetrate into any of the arts or Ways of traditional Japan, one must acquire at least a basic fluency in Japanese. Further, the aspirant must familiarize himself with the specialized idiom of the particular art he pursues. Why? For at least three reasons.

First, the great majority of practitioners, masters, and authorities in these arts are native Japanese, and most of them do not speak English. The serious foreign exponent will, sooner or later, come into contact with these individuals. The ability to communicate, even on a very elementary level, will then be taken as convincing proof of a sincerity to learn.

Second, because Japan in the later feudal period was isolated for the several centuries in which these arts were created and developed, they are, in pure form, extremely difficult for the modern non-Japanese unacquainted with Japanese culture to grasp beyond the superficial level. A fluency in the terminology of the art and an understanding of the grammar and syntax of Japanese is a valuable avenue to progress into the depths of the art.

Third, many words used in the combative arts of Japan may be used as well in ordinary Japanese conversation, but to the martial artist they may have a different connotation. Other terms may be specialized within the Japanese language and be unfamiliar to the average Japanese speaker. In both cases, the foreign practitioner should understand that these words simply

do not have an exact English equivalent. Their use by non-Japanese speakers who are involved in the traditional Japanese arts is not an affectation. It is a necessity for learning and for understanding.

This book is a collection of some of these words. I have rendered their kanji in the sosho style. Sosho is the abstract, "shorthand" form of writing; it is, in a way, the bones of the kanji laid bare. It simultaneously captures the essence of the character and unveils the beauty of form that elevates calligraphy in Japan to a true art form. The kaisho, or standard block form, is also illustrated, along with a philological exploration of how the kanji evolved from its earliest pictographic inspiration to the meaning it might have for the martial artist today.

The relationship between the written language of Japan and its martial Ways is an intimate one. Investigating it opens doors otherwise closed, introduces concepts and ideas that cannot be communicated any other way, and conveys a sense of the immense cultural legacy these arts represent. I hope the reader will be stimulated by the calligraphy and the essays concerning them and that this book will serve as a key that will lead him into further study, reflection, and contemplation on his own.

A Note to the Reader

Reading kanji and taking the initial steps in appreciating their artistic merit requires an understanding of their basic composition. Kanji may be divided into six kinds. The oldest are the original *pictographs*. These are literally word pictures, such as the square grid that looks like an agricultural field and has that meaning. *Ideographs* combine two or more pictographs to create an associate meaning. Pair the "field" with another pictograph of a "thick arm," and the result is the ideograph meaning "one with the strength to tend the field," that is, "man." *Indi-*

cators denote abstract ideas, such as numbers. Combine three horizontal strokes with "field" and the meaning is obvious: "three fields." *Phonograms* are strokes within the kanji that convey their correct pronunciation. *Deflectives* represent the logical conclusions of some kanji compositions. Adding the pictograph of a "mouth" to the ideograph for "ten" creates "old"; it denotes the "spoken wisdom of ten generations." Finally, there are *loan characters,* philological anomalies that defy any explanation. How, for instance, the pictograph of a bird on a nest has come to denote the direction "west" is a mystery.

Any of these elements may appear in a character as a *radical.* The radical serves as a reference to the general meaning of the word. While radicals can be words on their own, more often they are part of a compound that makes a kanji.

Difficulties with the semantics of the Japanese martial arts and Ways begin with how to refer to them. In Japanese, they are called *budo, bujutsu,* and *heiho,* among other terms. Some scholars have made a linguistic distinction, classifying the feudal-era martial skills of the samurai as *bujutsu* (martial arts). These researchers label the modern, martially oriented disciplines *budo* (martial Ways). The nomenclature is convenient but not always accurate. In fact, some martial systems called themselves "budo" as far back as the medieval age. Some wholly modern forms reject that term and insist upon being called, for instance, *shin-kobujutsu,* the most accurate translation of which is "new-old martial art," which gives some idea of the problems in making sense of all this.

It is also an oversimplification to label all the hereditary class of fighting men of old Japan as "samurai" or "bushi." It is misleading to think of the warrior class in that country as a homogeneous group that did not change over the centuries. There were periods when these individuals were martially and

morally vigorous, and other times when they were indolent dilettantes. Nonetheless, *bushi* and *samurai* (and the Western title *warrior*) are used interchangeably here, with a plea for the historian's forgiveness. The concepts and ideas described are those of the classical Japanese man–at–arms at his best, even if this was not always the case.

I have chosen the term *bugei* to describe both the classical arts of the samurai and those modern disciplines practiced on a worldwide scale today. Most of the terminology here applies equally to both; where a distinction exists I have made note of it. Likewise, I refer to all practitioners, ancient and modern, as *bugeisha*. (And while the masculine pronoun obtains through-out, this is for the sake of precise grammar rather than any neglect of female bugeisha. Japanese is gender neutral in this regard, and so are the bugei.) The title *bugeisha* is inclusive. It refers to all those adherents now and from the past who have sought to discover through a serious pursuit of these noble arts a more worthwhile way of life.

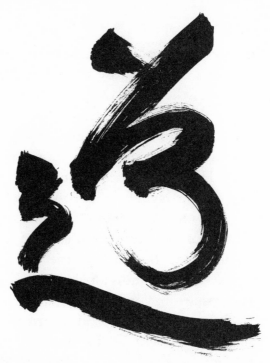

1 Do: The Way

道 The Way, at the beginning, is obscure. Even the initiatory steps are wreathed in mist. The heights toward which the path leads apparently are closed within clouds, which seem, from a perspective below them, beyond penetration. And that is for the best, for to see too clearly what lies ahead would be altogether too intimidating. The sobering realizations come only in retrospect: the traveler on such a Way has left behind a familiar and comfortable place; he has entered a journey more challenging, more rewarding than ever he could have imagined at the start. Further along he comes to see that his Way is to a destination still utterly unfathomable yet intensely attractive to him.

It is not a physical transportation, this Way, though rare is the bugeisha who finds he can travel its length without leaving home. The Way is a journey of the mind and the spirit and,

ultimately, the soul. The engineering of the Way is a contribution of the Taoists, those ancestral savants of China whose philosophy of the Tao—Do in Japanese—urged a life attuned to the currents of nature. Under the calligrapher's brush, *Do* is written as a compound character. The strokes for "principal" or "main" are joined with those of the radical for "movement." Hence, Do is an "important road," a Way to follow in harmony and synchronization with the vicissitudes the universe provides, a path along which to discover for oneself the essentials of a worthwhile life.

In this sense, the traces of the Way are very old. It took form the first time an individual engaged in some activity with a consciousness beyond the utilitarian, past the restrictions of the ego. True, the Do may produce art. It may be of practical value. But the attainment of the Way is in the *process*. It is doing a thing not for the sake of doing it; it is doing a thing because the doing releases us from certain constraints of the limited self: narcissism, self-centeredness, preoccupation with the fears and worries and doubts that diminish us in daily life. The Way draws us into the domain of the potential self: self-realization, self-cultivation, and self-perfection.

The Do is both singular and universal; it is open to all with the resolve and inclination to walk it. Those who do, however, take a variety of disciplines in approaching it, for the Do extrapolates from the specific to the general. Tea ceremony, flower arrangement, gardening—each is a route of the Way. The route chosen by the bugeisha is the martial Way. While the particular form the Do takes does not matter, the Do of the bugeisha brings him into a most immediate confrontation with the elemental struggles of reality: life and death, pain and comfort, temporal matters and matters of the soul. The martial Way requires moral stamina along with visceral and emotional courage. It demands a social conscience as well as physical endur-

ance. To be sure, each of these qualities will be tested on the journey. They may, as well, be purified and fortified in the process. But they must be present in the individual in some degree from the onset if he expects to journey very far.

As a traveler of the Way, the bugeisha is oriented by a compass sensitive to the very center of Japan's traditional culture. The geography of this culture is the landscape upon which all the Ways of Japan have been laid and paved. The extent to which the bugeisha will familiarize and adapt himself to the landmarks of this culture will have much to do with the success of his passage.

An individual embarking on the martial Way must be brave and virtuous. He must possess a sense of commitment and a sensitivity to the values of the past. In spite of having these laudable character traits, the would-be bugeisha will also have inner uncertainties, including a suspicion something is missing in his life, something vital. And so he sets off on a path to mysterious destinations. He does so in spite of observations by others that such a Way is naive, outmoded, or idealistic. He goes because he knows others have gone before, because the unchanging direction of the Way attracts and calls to him. He goes because he is compelled. He has set out on a journey of a lifetime because he senses that, as the kanji for Do reveals, this road is the principal one for him. This Way is the one to lead him to a place very much worth the going.

2 BU: MARTIAL

武 In Asia, since ancient times the spear has been the symbol of the warrior. Rendered into calligraphy in ideographic form, the spear is a basis for many kanji. It is the root for *bu*, the prefix used in a number of words concerned, not surprisingly, with things of a martial nature. There is *bugei* (martial skills), *bushi* (the feudal class of warrior gentility), and *buke* (an ancestral warrior family).

It would seem logical that the character for the spear alone would be sufficient to connote *military*. But, in making up the kanji for *bu*, the brushstrokes for *spear* are accompanied by additional strokes that mean "suppressing a revolt." The whole character for *military*, then, actually refers to "quelling an uprising by use of the polearm."

Smothering insurrections has been the purview of the military throughout civilization. Nowhere more than in Japan has

it been the task of the warrior caste to enforce order. In the best of times, these military efforts restored peace and promoted culture in Japan. In the worst, they reinforced cruel oppression and crushed the spirit of the land. And so the bushi, the only well-armed class of old Japan, were both heroes to the people as well as tools of tyrants.

The spear used in the Japanese martial arts, the *yari,* is not a projectile weapon. It was wielded on the battlefield like a pole-arm. The yari's tip is pointed for thrusting, but the blade typically is long and edged on both sides. The yari could be used to slash either right or left. So it is apt that the yari, a weapon to cut in opposing directions, would form the basis of so many words dealing with the martial. Just as he may today, the warrior in feudal Japanese society could cut both ways: for good or for evil.

3 KEIKO: THE PROCESS OF TRAINING

警古 The English-speaking bugeisha has some difficulty explaining what it is that he does. In relating to the inner motivations that call for him to set out on the Way, he falters. He stumbles too, in expressing what it is that he *does,* day in, day out, year after year—what it is that occupies his time in connection with the martial Ways. The kendo exponent, for example, off for an evening's exercise, may say he is going to "practice" kendo or "learn" kendo. He may say that he "takes" kendo or that he has kendo "lessons." He may even say he "does" kendo or that he "plays" kendo.

Somehow none of these adequately communicates the experience of kendo or any other bugei. It might be accurately said

that a child exponent is going to kendo lessons. But how about a seventy-year-old master of the art? If a new technique is being introduced, is it appropriate to call such teaching "practice?"

In Japanese, the act of doing a bugei is described comprehensively with the word *keiko*. Keiko is "to involve oneself in a process." To train, to practice, to learn, or to engage in—all these are conveyed by the word *keiko*, and so keiko is the verb the Japanese-speaking bugeisha will use conveniently to describe what it is he does. His Western counterpart is likely to envy the term. An English equivalent for *keiko*, were there one, would make communication easier for him.

But, for the bugeisha who uses it, the linguistic ease of *keiko* can blunt the real meaning of the word. The non-Japanese-speaking bugeisha struggles for a verb broad enough to convey the inducements that draw him to the Way. The struggle stimulates him to think about why some possible word choices are inappropriate. Does he "play" a bugei? If so, it is an indication to him of a lack of seriousness on his part. Does he "practice"? If so, then for what, exactly, is he practicing? Is it to accomplish something tangible, or is practice for practice's sake sufficient to propel him forward?

The bugeisha for whom *keiko* is part of his native vocabulary may never once pause to intellectualize in this perspective. He should, however, and the means to start is through attention to the word itself. The *kei* of *keiko*, written at the top, is a kanji rarely used today; it means "to cogitate," "to think," or "to consider." *Ko*, brushed at the bottom of the word, is written with numeral "ten" atop a "mouth." *Ko* is the spoken wisdom of ten generations, that is, "old."

Keiko means "to meditate upon the old." It describes perfectly the course followed by the bugeisha, a wayfarer who is dependent more than most upon those who have walked before

him. His training, his practice, and his learning are all functions of keiko. All are, in one manner or another, a contemplation of the past. No matter what he may call his participation in the bugei, if he enters into it in the spirit of keiko, he may be confident he will not stray from the path.

4 SABAKU: MOVEMENT

裁 The bugei of Japan are a panopoly of movement. Exponents jostle and clash . . . weapons of steel, bamboo, or wood, twitching and flashing . . . fists and feet flicking, lashing out . . . the jolt and lunge of sumo or judo grapplers in their efforts to topple one another . . . the arc of the blade's draw, the thrust of the staff, the flight of the arrow The key to all these motions, from the perspective of the calligrapher's brush, is found in cutting a bolt of silk for the making of a kimono.

If a kimono maker cuts with judicious care, he will get every piece he needs from one length of silk without any of the precious cloth being squandered. The character *sabaku* is literally "to judge decisively a cut." The movements of the bugeisha are imaginatively described with this word.

Sabaku is not random motion. The bugeisha does not engage

in the kind of nervous fidgeting or displacement observed in untrained men or prey animals when faced with the stress of aggression. All his movements are calculated. Energy is conserved. Sabaku is the movement of the predator. Tigers never posture or roar when attacking; hawks in the act of taking their quarry do not flutter or scream. The actions of the predator are the essence of economy. In the midst of chaos, fear, and mortal danger, they appear to be almost relaxed.

Perhaps it is this ability to relax, to move without superfluity, to release a burst of power only at the very instant it is needed that allows the expert bugeisha to continue his practice long after the age when athletes have retired from their activities. Indeed, the senior exponent of the martial Ways moves with a grace that is almost leisurely. While younger, "stronger" practitioners are exerting all their power throughout every movement or exhausting themselves in unessential motions, the senior bugeisha's actions seem in comparison sedate and almost parsimonious. Even so, his attacks always find their target; his parries materialize languidly yet with stunning effectiveness. Always he is in exactly the correct place he needs to be, never a moment too soon or too late.

It is no coincidence that the lives of most master bugeisha have been ones full of activity, even in old age. When death comes, it is rarely at the end of a long and debilitating illness. Instead, they are engaged in a physical pursuit of the Way almost until the moment of their demise. They live completely, not an hour dissipated, until finally, like a candle burnt to the very end, their flame is quietly extinguished. In training, as in life, the sabaku of the bugeisha, cutting with complete and absolute precision, wastes not a shred of cloth.

5 Kata: Form,
the Architecture
of Meaning

形 In the traditional Japanese farmhouse, light and ventila-
tion were provided typically by removing the clay plaster
from a section of a wall's interior and exterior, leaving a hole
and the exposed bamboo latticework lathing. This kind of rus-
tic window, a *renji-mado* (lattice window), was incorporated
into the architecture of the tea ceremony, and many tea huts
feature renji-mado. The light from such a window is beauti-
fully filigreed by the grid of latticework, leaving a play of
shadow. It is a kind of illumination defined as much by the
pattern of shadows as it is by the presence of light.

Patterns have emerged in the bugei. The consummation of
countless experiences in battle, these patterns were brought to

their final form at a price of blood and carnage and intense effort. They were sequences of combat: attacks and counters; the exploitation of weaknesses in stance, weaponry, and armor; the manipulation of every facet, mental and physical, that increased the odds of destroying an enemy at close-quarter conflict. These sequences of fighting engagement are the *kata* of the bugei. For the bugeisha, they are indispensable. They bring coherence to his study. Kata are the framework around which his training is organized.

The catechisms of the kata are not unique to the bugei. Every Japanese art employs preset patterns given to initiates to emulate and master. The practitioner of tea performs a kata of tea preparation with precisely the same gestures and ritual as were used two centuries ago. He has learned it exactly from his teacher, who learned it in his time the same way. So it is with the kata of the bugei. Devised by warriors and refined by their successors, martial kata gradually assumed a fixed form. The modern bugeisha who assimilates and exercises them is thus tapping into a deep source of knowledge, a pedagogy that has proven itself in the firestorm of battle.

Those lacking a firsthand acquaintance with them are unlikely to take such a respectful view of the classical combative kata. They will interpret them to be a sterile, mindlessly repetitive imitation with little relevance to real fighting. For those not involved intimately with them, the appearance of kata is one of a highly choreographed ballet, with rigidly set patterns devoid of any creativity or spontaneity.

Only from the inside perspective of the bugeisha is the true nature of the kata revealed. Involved with it, he realizes that kata provide challenges in technical application, in timing and distancing, that will require a lifetime to fully explore. What appears to the outsider to be a slavish apprenticeship to robotic form is to the insider a method of instruction that allows him

to achieve his unique potential. The practice of kata brings the bugeisha to encounters that open for him opportunities for creativity and individual self-expression undreamt of by those who have not followed the Way. Within the structure of form, boundless freedom awaits. Through imitation, self-consciousness is subjugated. The true self is uncovered. It is a self that marks each kata with its own, inimitable qualities.

A lattice grid with rays of sunlight penetrating it—this is the kanji pictograph for kata. The nonpractitioner sees only the light admitted by the renji-mado, for his point of view, looking in from outside, is restricted to the entrance of the tea hut. It is to those who have entered into the recesses of the room that the textures and subtleties are disclosed. Kata, too, is a very special sort of illumination, for it can shine a light into the spaces occupied by the human soul.

6 RYU: THE TRADITION

流 In Japan one is rarely out of the reach of the sounds of water. Water gurgles in roadside ditches, splashes down mountain freshets, sloshes in neck-deep pools at outdoor baths. A generic term denotes the flow of water: *ryu*. It is a poetic word. *Ryuto* is the practice of drifting candlelight lanterns on a stream during summer festivals honoring the dead. A *ryusei* is a falling star. So it is congruent, in this land of running water and expressive language, that *ryu* would be the kanji for the flow of formal traditions of all the arts of Japan, including the bugei.

Prior to the fifteenth century, military combat in Japan was literally hit or miss. Success on the battlefield depended upon the fighting man surviving long enough to evaluate and learn from personal experience. It was not until the strife-ridden Muromachi age (ca. 1300–1600) that warrior clans began to or-

ganize their professional skills, to polish those that were most effective, and to transmit them to other clan members. Such evolution allowed learning from the accumulated experiences of others. It was the foundation of the martial *ryu*.

The martial ryu assumed distinctive identities based upon specific strategies they adopted, particular weapons they may have favored, or even the geographical location of the individuals who created them. Some ryu were the exclusive domain of a single clan or fiefdom. Some may have aimed their teachings at the lower-ranked samurai; others may have been devoted to educating the senior officer. The curricula of a few ryu were limited to instruction in one or two weapons. Most taught methods for using a number of different arms. Yet no matter what the course or breadth of instruction, the form of transmitting skills through the ryu was—and, in those still extant, is—consistent. They are passed on from one generation to the next, preserved as a living structure.

The ryu do not exist as autonomous entities. Without loving and strict ministration, they will soon stagnate and evaporate. To keep them alive and fresh and flowing is the responsibility of those bugeisha entrusted with their care.

7 SHI: THE MASTER

師 No one, no matter how well intentioned or self-prepared, can travel very far without the guidance of the master. He is indispensable. Even so, of the many who consider seeking him, only a few will begin the search. Fewer still will have the persistence to continue on until they find a master. And once in his presence, how many will be left undaunted to learn from him?

The figure of the master looms in the imagination. Portrayals of him as taciturn guru, as all-knowing sage, as eccentric ascetic—all these miss the mark in most instances. When not actually training or teaching, the master is more likely to be garrulous and to be the first to admit there are gaps in his knowledge. Rather than being a hermit, he is more likely to be an accountant, farmer, or train conductor. Whatever his personality, the master of the bugei is characterized by some inevi-

table traits. He has traversed the Way, he has explored its main route and many arterial byways, and he has the skills and desire to lead the next generation along the same path.

In such arts as the bugei, the role of the teacher cannot be underestimated. The martial Ways are not transmitted by written instruction. One's fellow trainees are of little help: they, too, are learning and are often enjoined from even practicing with one another without supervision. The master is the sole source of teaching. Without him, the student blunders about blindly. A dead-end, convoluted side trail is mistaken for the Way. Worse still, a precipice beckons and the student, without instruction, is lost. Only with the guidance of the master is there hope for following the Way correctly.

Several terms in Japanese denote a master or a senior teacher: *shihan, shisho, doshi, renshi, kyoshi, hanshi. Shi,* their common element, is based not on some pedagogical concept, as one might suspect it to be. Its derivation is, instead, topographical. The radical for *shi* is that for "hill." Additional brush strokes are those for "a growing plant." A "tree-topped hill" becomes a logical metaphor for a teacher if, as with so many Japanese words, we consider Japan's martial heritage. To observe his troops in battle, their commander took a hilltop position. The advantage of height was imperative to get a broad view on deployment and strategy. Because this also situated him attractively as a target, the canny general, if possible, chose a forested rise. Concealed by the background of trees, he could observe and direct without attracting attention to himself.

The master watches and teaches from a similar perspective. His character, thoroughly annealed by the process of the Way, is devoid of the insecurities that make the ego restless. He is without pretension. His humility and self-effacement reflect a personality of such strength that no artifice can be discerned in him. The personality of the master serves him well in his role

as teacher. He conducts instruction quietly. He stays in the background somehow, even though he is at the center of all the training. He is the general on the hilltop.

The master's subtle method of imparting instruction will be understood by only a minority of those who come to train under him. Those few will watch him, just as the more talented soldier will keep an eye on his leader to determine the course of the battle. In this way, the master is assured that only the most persevering and astute disciples will emulate him. They will be the students willing to trust the master completely, and they will have the desire to walk in the steps he has already taken.

From his position on the hill, the master has a point of view few others share. He is at all times to be watched, his directions obeyed. He alone can guide on this particular journey. The wise bugeisha will follow.

8 DAN: RANK OF ADVANCED PRACTICE

段 To "carve steps up the cliff" is the literal meaning of the kanji for *dan*. To the more experienced bugeisha, it would appear to be an ideal word to describe his progress. And so it does. In those modern forms of the bugei that recognize advancement of skill by the awarding of black belts, such ranks are known numerically as *shodan, nidan, sandan,* and so forth. But while an examination of the kanji can lead to deeper understanding, it can also mislead and cause the unwary to be led astray from the path.

When he starts out along a journey of the bugei, the beginner apprehends that he has set out across an utterly baffling landscape. Nothing is familiar. He proceeds under the direction of his master and, in time, landmarks appear. The bugeisha ascer-

tains a direction. In terms of technique, he sees in his teacher a standard, a model that he wishes to meet, and he works his way toward it. He climbs closer and closer to the top of the cliff. As he does, he may reach certain perches and be rewarded with ranks or promotions, and he may pause to look back at the steps he has carved, measuring his progress.

Upon reaching what he perceives as an ideal goal, the journeyman bugeisha is surprised to discover something entirely different. Sometimes it will be a word from the master; more likely the lesson will be imparted by the master's physical example. In either case, the bugeisha is suddenly confronted with the fact that what he thought was perfection of the technique was merely the *introduction* to it. An entirely new vista has opened up for him. What had been his destination has been revealed as a pass through the mountains, one that gives way to another broad view waiting to be explored. Lying beyond the momentary refining of his art, the bugeisha discovers places that in turn and in time will lead him to other regions.

And so, pausing when he is awarded his dan, the bugeisha may indulge the opportunity to look back and contemplate his progress. He may stop to glance back down the cliff he has just scaled. But he must be prepared to turn his gaze from the heights he has so recently gained; he must prepare his ascent of the peak he suddenly finds before him.

9 HEIHO: PRINCIPLES OF WAR, PRINCIPLES OF PEACE

兵
平
法
"Heiho is heiho" goes an axiom that illustrates a role kanji play in understanding elements of the martial Way. Redundant in romanized form, only through the kanji does meaning emerge. *Hei* can be written to mean "war," with a kanji pictographically depicting a battle axe grasped in both hands. Written with a different character that is pronounced the same way, *hei* can also denote a "peaceful prosperity." (This character is pictographic in origin, too, depicting a water lily coming up to rest tranquilly on a pond's surface.) So, through a knowledge of the characters, "heiho is heiho" may be translated to mean "the principles of martial matters are identical to the principles of domestic peace."

The character common to both ways of writing *heiho* is *ho,*

"laws." To write *ho,* the calligrapher draws the radical for "water," then, next to it, a "container." A vessel tight enough to hold water: the kanji captures the essence of the word well, for Japan was, during the feudal era, a country of strict, confining laws. From the humblest peasant to the aristocrat, the Japanese of old were subject to a legal governance over nearly every aspect of their lives.

The samurai were not exempt from laws. The *Buke shohatto,* a wide-ranging set of promulgations enforced by the Tokugawa regime, specifically governed the warrior class. If, for instance, a bushi's relative was murdered, he was not necessarily free to seek the revenge that is a central plot device in popular historical novels and period movies in Japan. He first had to apply to his lord for permission to leave his duties. If the murderer fled, the samurai might have to apply for funds to support himself and his family while he searched for the villain. And once the samurai was allowed to seek revenge, he could not, under law, return to his lord's service until he had completed the mission.

Ideally, the strictures of law that rule the bushi so severely would have made him more sympathetic to the plight of other classes. The reality, of course, was that the samurai tended to worry about himself, as do most people in most times. Yet it would be unfair not to recognize the many samurai who did consider the welfare of other castes. Many were influential in creating beneficial government policies, and among the leaders in education and politics that brought Japan into the twentieth century are found the names of several renowned bugeisha.

Inevitably, these bugeisha applied martial principles to their philosophy of government. Courage, integrity, respect for others—all these conventions of the martial Ways were translatable to the practice of government, as were those principles energizing a sensitivity to treachery, a vigilance in the face of danger, a calm spirit during crises. The example these warriors

left, their ability to implement the laws of the battlefield in for-
mulating laws for the betterment of their society, should be a
source of inspiration for the modern bugeisha. If, in his train-
ing, he fails to see the application of its laws in citizenship,
then, however he might progress in martial principles, he will,
in perfecting the Way, fall short of its real goals.

10 Oku: The Secrets

奥 A wife, in Japanese, is referred to as an *okusan,* a "Mrs. Inside." Okusan has commonly been translated as a dismissive term, one meant to connote that a wife is one who stays at home like a servant. *Oku* does mean "inside." To be more exact, it means "deep inside." The character for *oku* is built of two components. The one on top is for "rice within a building." Below is "hands pushing." So *oku* is the placing of valuables in the most secure treasury. The *okuma* is the deepest, safest part of the Japanese house. The *oku-no-in* is the innermost sanctuary of a Shinto shrine. Viewed in this context, an okusan is the woman who is privy to and protector of her husband's most private self.

Within the ancient forms of the bugei, the ultimate principles of a particular art or tradition are called the *okugi* or *okuden,* the "hidden teachings." When the goals of these arts were lethal in

their consequences, oku teachings were carefully transmitted only to the most capable and trusted of a master's disciples. Even today, a practitioner must demonstrate exceptional persistence and commitment before he will be initiated into any okuden.

One obvious reason for the exclusivity of the okuden's transmission was that these secrets were more dependable and effective in battle when they were known by fewer bugeisha. An equally important reason involves the structure of all the teachings of a bugei. These are often assumed by the outsider to be hierarchical in nature, progressing upward to some ultimate martial "enlightenment." In fact, the teachings are spiral, circling around, returning to the basics again and again, each time in a more detailed and comprehensive fashion. The okuden are those secrets kept at the center, at the very heart of the art. It is not that they are so complex or so sophisticated that only the most advanced can grasp them. The okuden are hidden because such teachings are sublimely simple, refined to an intensely concentrated center of the spiral. Only the adept who has worked his way through the travails of the outer gyres can truly understand and appreciate their value.

11 KI: ENERGY

気 From China and Japan have come spectacular tales of a power that seems supernatural. Tales of men able to toss an enemy through the air with a flick of the wrist and withstand the most vicious strike without so much as a blink. The stories become even more fabulous. The power can be extended to move objects without touching them. Opponents may be struck dead with a distant gesture. And the power, according to the tales, can be manipulated to heal and perform other miracles, as well.

In Chinese this esoteric force is called *chi,* in Japanese, *ki.* As with so much that originates in the Orient, ki has acquired a mantle of exoticism. Martial artists accustomed to speaking of it in hushed terms are often startled, then, when they learn something of the Japanese language, to hear of ki in distinctly plebian terms. In the training hall, phrases and words such as

aikido (the Way of harmonious ki) and *ki o musubi* (the uniting of ki) have a lofty tone. But *ki* also occurs in Japanese conversation when discussing the weather (*tenki*), lunacy (*kichigai*), or even an automobile's carburetor (*kikaki*).

What may be even more perplexing are expressions such as *ki ga awanakatta,* which means "we don't get along well together," or *kimochi ga warui,* "the 'vibes' are not good." The confusion surrounding the many identities of ki may clear through an examination of the kanji used to write it. *Ki* is a composite character, joining the kanji for "raw rice" with other strokes above it representing steam rising off the grain as it cooks. Ki, then, is pictographically a plastic energy, invisible except through its effects. We do not detect the vapor coming off the rice pot, but we can see and hear it rattling the lid. In Japanese, *ki* refers to an organic force that may take myraid forms; it may describe the climate, an individual's personality, or those vague sympathies and sensations we have all experienced.

In Chicago or another American city, a conversation might include usages for *soul* ranging from the theological to those describing a cuisine. Similarly, *ki* can be used in Japanese to describe things both sacred and profane.

12 SHIN: THE MIND

The etymology of a kanji is not always easily traceable. Scholars may disagree on how one developed or what it might originally have represented. *Shin* is such a kanji. Requiring no more than four touches—two strokes and two dots—of the calligrapher's brush, *shin* indicates "mind" or "heart." One theory maintains the strokes for *shin* are a stylized rendition of the human heart with its four ventricles. Another theory has *shin* as a long boat, rudder behind, being piloted downstream by a watchful tillerman. The latter interpretation is imaginative, doubtless. But it has a certain appeal in explaining the place of *shin* for the bugeisha.

That bugeisha is busy in the training hall when, without warning, in bursts a wild-eyed intruder, a knife brandished in his hand. At that moment, what occupies the mind of the bugeisha? A dozen thoughts or more, sensations more than actual

intellection, but if his consciousness could be recorded, slowed, and played back, it would probably start to run along this stream:

"What does this guy want? Robbery, or something worse? Is he crazy? That knife looks really sharp; if he just touches me with it, he could do some serious damage. Can I handle him? Should I try?"

Given the situation, a millisecond or two longer and the mind will find more to occupy itself:

"Why does something this ridiculous have to happen to me? A lunatic with a knife comes out of nowhere into my life, and now I have to deal with this."

An eyeblink later and, the consciousness being what it is, it will add to the chorus the chatter of the ego:

"How will it look to others if I try to resist this fellow, take away his knife, and I fail? Not only will I be injured, maybe killed, but I will lose the respect of those who admire me because of my fighting skills. My reputation is on the line!"

With so many inner voices clamoring, the bugeisha may have some difficulty grasping the reality of the situation—which is precisely his problem at that moment. When perception is distorted, responses will be hesitant or inappropriate. Preoccupied with fragments of fear, inchoate suppositions, egotism, the bugeisha is no longer confronting the real. He is instead entertaining a series of illusions. His reactions are bound to be influenced by the illusions.

The example is extreme, yet every day the bugeisha is susceptible to having his mind clouded by illusion. It is inherent in the human condition. The job opportunity passed up because it requires a move to an unfamiliar city, the fear of flying, racial prejudice, lust—how much of such trepidations and expectations are based upon illusion, preconceptions that exist only in the mind? In encounters of life-and-death seriousness, the

mind's tendency to conjure can be fatal, and so the bugeisha must be taught to deal flexibly with the most critical of confrontations. Because he knows that the training hall is a mirror for life, the bugeisha knows that the benefit of strenuous practice lies in an enhanced ability to see all things for what they really are, stripped of his preconceptions and fears, free from self-deception.

Like the boatman steering his craft, the mind can be so distracted by illusions—What rock might be hidden below that ripple? What cataract could lie behind that bend?—that it is impossible to truly see the river. Cognizant of that danger, the bugeisha keeps his mind set firmly on the tasks of training that his master has laid out for him, confident that these will be vital in steering him along other paths as unerringly as the one he has now chosen to follow.

13 KEN: THE SWORD

剣 To test a sword crafted by the master smith Muramasa, its owner held the blade's edge against the current in a stream. A leaf floated by; it touched the blade, and by the force of the current alone, it was sliced cleanly. The test was considered an ultimate trial of a sword's quality—until someone thought to try it with a sword made by Muramasa's master, the great Masamune. The Masamune sword was thrust into the stream, and another leaf swept toward it. Then, miraculously, the course of the leaf changed. It floated *around* the deadly edge, sailing on intact, as if the Masamune sword possessed a beneficent power beyond that for simply causing destruction.

The sword, or *ken,* along with the jewel and the mirror, is one of the three sacred treasures associated with Japan's mythic creation. The crafting of the ken, too, is veiled in a ritual of mysticism. The swordsmith, even today, works at his forge

attired in the white garments of the Shinto priest. Accompanied by apprentices wielding long-handled hammers, he chants and bangs a rhythm on the anvil, as a bar of molten iron glows and is then smashed into fiery sparks. Quenched, refined, the metal is flattened and folded again and again to make thousands of laminations. The process takes place before a Shinto altar and other consecrated trappings adorning the smithy, and it includes steps both religious and technical known only to the smith. The product is a weapon to inspire a kind of worshipful awe, as did Masamune's blade. The ken exists in a dimension between the substantive and the fantastic.

The kanji for *ken* has a simple radical, two strokes representing the long blade of the sword, and another component that means "a combining." A combining of what? Perhaps of the fire and prayer and pounding of steel that produce the sword. A combination of its edge, hard and keen as a diamond razor, and its spine, sturdy and flexible to absorb the shock of cutting. The "combining" in the kanji could refer to the sword's incarnation as an object of beauty and as a brutal tool for cleaving a human neatly at any angle. Or could it be the combining of the reality and the legend that, like the test of the ken of Masamune and Muramasa, have long characterized the dual nature of the Japanese sword?

14 IRU: ENTERING

入 To enter. To step into. To penetrate. *Iru* is an obvious pictograph for the calligrapher. A short horizontal line represents the ground; pushing into it is a bifurcated root made with two slanted vertical strokes of the brush. Iru is a fundamental principle for the bugeisha, one he will continue to perfect for a lifetime.

The bugeisha begins to learn technique typically as a solo exercise. When he has familiarized himself with various movements, he commences exercising them against a partner. At this point, he may be frustrated to find that the techniques he thought he'd learned well by himself are, when performed against another, weak and ineffective, even when his partner is cooperating.

Often the problem is that the methods the bugeisha has learned are directed against specific targets, with no attention

given to controlling the opponent's center, his core of stability. To affect another person, the bugeisha learns eventually, he must enter that individual's space. A principle of all throwing arts is that one must enter the space of the opponent's stable point, make it one's own, then gain leverage from that advantage. A weapon or an attacking limb is not just parried; its power is nullified in such a way that the attacker's entire body is upset, drawn or knocked off balance. The principles of battlefield strategy for the samurai were no different. Always to be considered is the matter of entering, iru.

Iru, for the bugeisha, becomes, too, a way of interacting with others in daily life. He does not keep people at a distance in dealing with them. He makes every effort to see from the perspective of others, to put himself in their shoes by implementing iru. Through iru, the bugeisha learns empathy.

Considerable courage is required to activate iru, no less in social relationships with others than in conflicts requiring the bugeisha to enter resolutely into the space of an enemy to defeat him. For just as a shallow root is likely to fail the plant, the bugeisha too timid to penetrate fully into his objective is unlikely to succeed at any worthy enterprise.

15 HYOSHI: TIMING

拍子 The familiar four-beat measure of Western music, ethnologists speculate, evolved from Western man's close relationship with horses. Walking beside or riding astride them, our association with horses goes far back in our civilization's history. Our music, according to this theory, reflects the relationship in the rhythm of four hoofbeats of the equine stride. If the theory is true, then where did the Japanese, who have little of our affinity to horses, take the inspiration for their music? From nature.

The drip of rain from a thatched roof's eave, winds soughing through pines, the staccato chirp of the cicada—these provided the rhythmic structure of Japanese music. It is nature that can be heard in the plaintive tones of the bamboo flute shakuhachi or the rustling twang of the koto.

Nature is evident, too, in the rhythm and timing—

hyoshi—of the bugei. Unlike the metronomic whack-whack-whack of the boxer at the speed bag, the cadence of the movements of the bugei are never steady. They are invariably inconstant in their motions, punctuated with pauses, moments of perfect stillness, and bursts of action. In this sense, the bugei's movements mimic not only nature, they are representative of combat itself, which is rarely a neat affair in terms of timing or anything else.

Hyoshi is written with two characters. *Hyo* depicts a "hand" along with a phonetic element that conveys "tapping." *Shi* is the kanji for "child." "A child's clapping." Rough in rhythm, unsteady and never predictable—the ideal pace to baffle an enemy.

The skillful bugeisha, polishing his abilities through practice of the movements of his art, is able to manipulate timing against an opponent. When he moves, his actions are as overpowering as a thunderstorm, swift and dynamic. When he pauses, there is the agonizing stillness that precedes a hurricane. Only the coolest of opponents can resist the urge to rush in against such stillness, thereby exposing an opening that would mean defeat. In perfecting his timing, the bugeisha is guided by the twin concepts of *sei* and *do*: activity and quiet. An understanding of the proper application of both these is essential to mastering timing. For those following the Way, to master timing in combat is the first step in perfecting a grasp of the rhythms of life itself.

16 KAN: PERCEPTION

感 While strolling through his iris beds, a great swordsman was inexplicably seized with a premonition of danger. He recounted the episode to an attendant who had been standing nearby. The attendant admitted he had reflected that at the moment he was preoccupied with the flowers, the master would have been vulnerable to an attack.

One of Japan's most famous warrior-generals was also among its most successful civil administrators. Despite his exalted status, he was considered to have skills of empathy that enabled him to understand the problems of the lower classes under his rule, and so he was regarded by peasants as highly as he was by the aristocratic elite. . . .

At a Kyoto noodle shop, a nineteenth-century bugeisha was eating while the proprietor and his wife argued bitterly about a new name for the shop. The bugeisha asked for a brush, ink,

and paper and wrote a clever kanji pun, one that could be read two ways: "delicious noodles" or "a child brings tranquility." The couple were astounded. An utter stranger, the bugeisha had divined their real contention: the infertility of their marriage. They used the kanji to name the shop, one which they eventually handed down to the child born less than a year later.

A sensitivity to the vibrations of murderous danger is called in Japanese *satsui o kanzuru*. The ability to relate to others, to see clearly from their perspective, is *kyokan*. To possess a sixth sense for detecting nuance and hidden feelings is *dairokkan*. In each of these is found the kanji for *kan*, "to sense" or "to perceive." *Kan* is used to describe sentiments, sympathies, and feelings, rather than the purely physical powers of perception. The substance of *kan* lies in the kanji for it. To write *kan*, the calligrapher first brushes strokes that indicate "a sharp tool used for trimming." Below that he adds the character for "heart" or "mind."

The concept of *kan* has a particular importance for the bugeisha. Accustomed as he is to a keenness in his weaponry, he is naturally comfortable in extending the metaphor for sharpness to his mental and emotional senses. This honing of the faculties of intuition is a sensitivity that begins as soon as his technical instruction starts, though the bugeisha might not be aware of it at the time. Because tuition in the bugei is so largely physical, with a bare minimum of oral or written teaching, the bugeisha must extend a kind of mental antenna to discover what it is that is really being transmitted. The master prefers empirical lessons. He may demonstrate half a dozen individual techniques, never explaining what principle all have in common. It is the task of his disciple to pick this up through his own effort, through the medium of kan. When the master does speak, his words are apt to be oblique or enigmatic. His student, if he expects to advance, must apply himself to cultivat-

ing perceptions that can receive the unspoken implications in the master's words.

As their relationship continues, master and student (and one may as well forget the sharpening of kan under circumstances other than those intensely personal ones where the teacher is in direct, one-on-one communication with his pupil) develop a rapport even more subtle. A gesture speaks volumes. The bugeisha understands intuitively much of what the master wants of him. He absorbs clues subconsciously during training. Even in the midst of energetic, full speed practice, he assimilates messages. It is all too fast for intellection, too subtle for cerebration. It is available to him only through kan.

Once he has experienced kan with his master, the bugeisha can apply it to other areas of his life. He can be more sensitive to danger, to the feelings of others, to those interplays of emotion that are weaving and unwinding about him all the time. For the bugeisha possessing the sharpened intuition of kan, interaction with others involves levels beyond and below normal communication. His mind is honed and provides him a tool that can penetrate into the innermost resources of those around him.

17 JU: PLIANCY

柔 In springtimes long ago, the sages of China were given to celebrating the season by sipping rare teas, composing verse, and dining on fresh bamboo shoots. The emergence of *takenoko,* as young bamboo is called in Japanese, is a remarkable phenomenon throughout Asia in the spring. Pushing up with vigor, green sprouts of bamboo can pierce concrete if it lies between them and the sun. They grow with such force that they can actually be heard in the act: a rustling sound of renewal in the quiet spring night.

The energy of all young shoots in the plant world is extraordinary, especially so considering their delicacy. The slightest breeze can bend new growth. With nothing more than a bit of twine and bamboo poles as guides, the Japanese gardener can train the young boughs of a pine in fantastic shapes. Tender plant shoots can be trained, bent, and swayed, but so long as

they are alive, they cannot be stopped. They are, for all their tenderness, indomitable.

The character for *spear* rests atop that for *tree* to create the kanji for *ju*. The etymological implication is that the growth of the tree has the power of a spear thrust. Ju—and this is the familiar prefix of *judo* and *jujutsu*—refers to the forces of pliancy. Ju is flexible strength, gentle potency. It is tenacity of a sort that embraces malleability. It bends to endure. Ju is durably soft; it receives in order to resist.

In a sense, ju is the process of turning to an aggressor the other cheek—only to use the movement of the turn to effect his defeat. The bugeisha who seeks to implement ju cannot settle for the brute stroke of the sledge. He needs the sensitive probe of the surgeon's scalpel. Ju requires a connection to the opponent, physical at the beginner's level, more mental at the expert's, to palpate for strengths and weaknesses. Once discovered, ju can be applied to adapt to both these, the physical and the mental. To establish this connection in the dynamic action of conflict, the muscles and mind of the bugeisha flex and conform to ever-changing circumstances. Like the bamboo's spring growth, the ju of the bugeisha is always yielding yet as unstoppable as the season itself.

18 DEN: TRANSMITTING TRADITION

伝 When a bugeisha speaks of his period of instruction he may use the expresssion that he "shared the mat" with his teacher for however many years he trained with him. By this, he indicates a relationship so close that master and pupil have been beside one another literally, sharing the space of a single tatami mat. The teacher has passed on skills and knowledge *directly*, intimately.

A *den* is a "transmission." The word is written with the combination of strokes for "person" and "rotating," connoting an image of an individual learning and then turning to hand the knowledge on to another. In Japanese, techniques preserved in written scrolls are *densho,* the "written" (*sho*) den. *Kuden* are those matters passed to another by word of *kuchi,* or "mouth."

Those revealed supernaturally by Shinto or Buddhist dieties are *shinden,* "divinely inspired transmissions," a word appearing in the titles of many martial traditions, such as the Muso Shinden school of swordsmanship.

While the den of a martial tradition may be recorded in scrolls or expressed verbally, those outside that tradition who gain access to this information have little chance of learning much of practical value. Such instructions invariably consist of vague references or riddle–like aphorisms. "The dragonfly always alights on the post" is the den of one school. "Likened to the wake of a sailing vessel" is that of another. These cryptic axioms suffice for the conveying of deep secrets because the bugeisha who receives them properly has spent an enormous amount of time apprenticing under his master. They have in common, teacher and student, the specialized vocabulary of their tradition, as well as similar experience in the physical actions demanded in learning it. The den, however opaque they may appear to the outsider, have meaning to the initiate and his master because the two have endured the long process of training together. They share an understanding of the den because they have shared a mat together.

19 FUDO:
THE IMMOVABLE DEITY

不
動
The bugeisha is, at heart, a conservative. He is a classicist. He is as stalwart—obstinate, his detractors would say—as a boulder in a mountain stream. The forces that batter and splash about him are those of fashion and romanticism. The bugeisha must be vigilant lest either erode his base and topple him.

During Japan's Meiji era (1868–1912), the country was rocked by a convulsion of Westernism. From fashions in clothing to the reconstruction of the national government, all that was imported from the West was the rage. Bugeisha in this period were often jeered as they traveled to their training halls, ridiculed for "playing with swords" in an age of firepower. Today, descendants of these warriors are frequently the target of

criticism for their refusal to graft onto or to modify their traditional arts, to make them more "relevant" in modern situations.

The bugeisha engaged in an ancient art has no desire to make it conform to these demands. Nor is he interested in manipulating his art for the sake of showmanship or sport. He strives instead to polish the great treasure that has been handed down to him. He seeks only to weld himself as one more link in a long chain. For him, these arts are vibrant and living antiquities of immeasurable worth. He would no more bastardize them than he would hack away the legs of a Chippendale chest to accommodate a modern apartment's low ceiling.

Romanticism, on the other hand, threatens to infect the bugeisha by flattering his ego. It paints his art in colorful hues of the chivalrous knighthood of a dreamy, mythical past. If the bugeisha succumbs to such notions, his training becomes a theater of derring-do. He exercises his imagination as vigorously as his body. This infection of romanticism may seem harmless. Its danger, however, lies in the encouragement of delusion. Heroics were a part of the life of the feudal Japanese warrior, certainly. But his true character was more likely revealed through quiet fortitude, steadiness in training, and in the meeting of his daily responsibilities. His Way was defined in a thoughtful adherence to the forms of those who preceded him and in recognition of the values these forms embody—in other words, classicism.

Fudo Myo-o, one of the protective deities of Buddhism, is portrayed in religious art brandishing a sword and a length of rope. The sword of Fudo cleaves through the torrents of illusion to expose crystal clear reality. His rope, metaphorically, is a lifeline keeping him anchored against the currents of capricious change. Fudo represents, for the bugeisha, the spirit of endurance. The kanji for the deity's name make this obvious.

Fu and *do* mean "without" and "movement." Fudo is a saintly protector, steadfast and incorruptible. The bugeisha stands like that boulder in the stream. With the image of Fudo before him, he cannot be shaken.

20 WA: HARMONY

和 A researcher doing her dissertation on *chado,* the Way of tea, interviewed several trainees at a famous chado school in Kyoto. She wanted to know specifically what it was that led these individuals to take up the art of tea ceremony. A consistent response she got from Japanese as well as from visiting Western students was that chado furthered them in their search for harmony.

Harmony is a reasonable motivation for following the Way of tea. The tenets of that Way are, after all, purity, simplicity, respect, and, of course, harmony. A scholarly curiosity led the researcher to return to the school to ask a follow-up question. What exactly, she wanted to know, did those students mean by "harmony?" In asking this, she discovered a striking distinction.

The Western tea trainees were almost universal in their defi-

nition: harmony meant a sense of inner contentment, the quality of calm self-acceptance. Their Japanese counterparts were equally consistent. They defined harmony as the capacity to get along with *others,* to sublimate the self for a greater cohesion within the larger social nexus.

"The pliancy of a rice sprout" placed next to a square representing the human "mouth" completes the kanji for *wa,* or "harmony." To be harmonious is to be considerate in verbal intercourse with others, to be civil, courteous, tactful. Much has been made of Japan—which in its frequently poetic language is called by its own inhabitants the "Country of Wa"—as a society forced into mutual accommodation by nature of its large population being crowded onto a limited land space. But wa has guided social relationships in Japan since long before its population burgeoned. It is more a function of the Confucian teachings, or *shushin,* that have permeated Japan for centuries. Respect—more than love or justice or the civil rights that have electrified Western culture—respect informs Confucian ethics. Respect for one's fellow human beings is pivotal in getting along with them. Harmony and respect become inseparable in traditional Japanese consciousness. Both are employed as a means of cultivating the self, which is a mechanism for fitting the self into the greater whole of society.

Since the pursuit of all the Japanese Ways, tea ceremony as well as martial arts, is so aimed at personal development and self-perfection, it behooves the traveler on these Ways to contemplate just how the individual interacts with those around him and how his Way might lead to real harmony—inner harmony as well as harmony with others.

21 OMOTE/URA: OUTSIDE/INSIDE

表
裏
The nonpractitioner is to be forgiven his skepticism when told that the modern bugeisha is uninterested in what is popularly thought of as "self-defense." After a demonstration of the bugei, particularly those that feature violent strikes or astonishing throws, the skeptic is likely to become an outright cynic. The bugei, even those appearing relatively passive, such as the solo exercises of sword drawing or archery, are, by their nature, militant. One who denies their apparently obvious bellicosity seems rather like the oenophile who, from the middle of his wine cellar, promotes abstinence.

The bugei are not unique among Japanese arts in this ostensibly contradictory nature. What is the end objective of ikebana? Why, it is not to create a beautiful arrangment of blossoms,

certainly. Is the tea ceremony a means of quenching thirst? No, not really.

The contradiction between the obvious, the observable, and the real has to do with the concept of *omote* and *ura*. Appropriately, the terms themselves have two meanings. In normal conversation in Japanese, *omote* and *ura* are "front" and "back," "outside" and "inside," "obverse" and "reverse." The kanji themselves refer to an almost prehistoric Japan when tribal hunters wore animal skins and needed words to distinguish between those worn with the fur on the inside and those with fur on the outside. *Omote* and *ura* occur in places we might expect—to describe the front and back surfaces of a coin, for example—but also in instances for which English has no direct equivalent. We would not think of an object like a sword as having obverse and reverse sides, for instance. In Japanese, it does, the *omote* describing the side of the weapon facing out when worn thrust through the belt, the *ura* that side against the warrior's body.

The duality of Chinese Taoism has left its indelible mark on Japanese culture, a possible explanation for the presence of *omote* and *ura* in most Japanese arts. The omote of an art is that which is on the surface, that which can be apprehended by casual, uninformed observation. Ask the foreigner what is happening at a contest of sumo, and he will tell you it is a couple of behemoths attempting to knock down or force one another from the ring. Ask a sumo afficionado and an entire world will be opened to you. The temple style of roof hanging above the sumo ring is adorned with brocade tassels of four colors, representing a white tiger god of the west, a green dragon deity of the east, and respectively, a red sparrow god and a black turtle god to the south and the north. Below its superficiality as a sport or athletic contest, the art of sumo has

an ura, a dimension of profound spirituality and hoary, venerable symbolism.

Ikebana may initially attract to the Way of flowers those wishing to create attractive floral arrangements. After entering that Way, however, if his master is a good one, the practitioner will come to see that beautiful bouquets are but the omote of ikebana. The ura of the art is in harmonizing oneself with nature, losing the ego through the rigid and demanding process of arranging floral geometrics in a timeless, fragile way.

So, too, the bugeisha who is drawn to the military arts for their promise of strength and outward violence is (again, provided his teacher is of a caliber to bring students into the level of the ura) taken below the surface. Behind the bugeisha's observable form is a Way of life, a journey toward dignity, respect for oneself and others, and a path exemplifying that which is moral and good and beautiful. It is not obvious. But it is most assuredly there.

Without doubt, the greatest danger the bugei face in the West (a danger shared precisely by other Japanese arts and for precisely the same reason) is the celebration of their omote and the concomitant ignorance surrounding their ura. The observable in a culture travels easily. The underlying spirit is most difficult to export. Displays of lumber smashing or dazzling exhibitions of skill that send assailants flying, martial sleight-of-hand— these examples of the bugei's omote have captured Western imaginations. Only through persistence and the guidance of gifted masters will the soul of Western exponents be captured in a similar way.

22 JUTSU: ART

術 The armor once worn by the samurai rests today in display cases in museums and private homes. Beneath great horned helmets, from where eyes looked out at death, there is a haunting emptiness. Gauntlets that protected a warrior's arms, from the shoulder down to the backs of the hands, are hollow now, along with cuirasses laminated to deflect arrow thrusts. These armored suits sit as if their wearers had paused to rest in them and then vanished, leaving behind nothing more than magnificent shells. . . .

We in this age are so removed from the time of the bushi it is difficult for us to return animation to the armor they have left. What little even most Japanese know of these unique men-at-arms is filtered through historical drama and literature. It is a mild shock, then, to see this armor suddenly come alive. At temples with religious or family connections to ancient martial

traditions, exhibitions of the classical fighting art of the samurai are performed on occasion. The men and women performing them are in some cases so elderly themselves that they totter (until they begin their demonstrations: then they become remarkably agile). Others are young people with enough respect and sensitivity for relics of the past to maintain them. In their expert and committed hands, the *jutsu,* or "arts," of the bushi are brought to life.

Jutsu is written with the radical element for "road" along with a character that acts phonetically to mean "twisting" and simultaneously "adhering." *Jutsu* is suffixed to all kinds of words to indicate an art form. The bujutsu are the martial arts, but the term is usually reserved for the martial arts specifically originating in the classical period of Japan's history, from the fourteenth to the seventeenth century. To call the bujutsu diverse is a considerable understatement. *Kenjutsu* is the art of swordsmanship. *Sojutsu* is the art of the spear. *Jojutsu* is the art of fighting with a stick; *bojutsu,* the jutsu for using a longer staff in combat. The jutsu of more esoteric weaponry includes *kusarigamajutsu,* the art of fighting with a sickle with a long, weighted chain attached. *Tessenjutsu* details the fighting skills used with an iron truncheonlike fan, and *shurikenjutsu* is the art of throwing small, bladed weapons. And these are but a few of the arts known collectively as bujutsu.

Nearly all the bujutsu were meant for implementation on the battlefield. They are truly *martial* arts, and therefore most were performed in armor. Demonstrated on a smooth, level surface, they may appear slow and ungainly at times. But on a killing field, on rough and dangerous terrain and when encumbered by armor, they make perfect and deadly sense.

The bujutsu incorporate methods and cognate arts that may not themselves be directed at fighting but that were necessities for the samurai. *Sueijutsu* is the jutsu of swimming. *Bajutsu* is

the jutsu of riding a horse while fighting. *Hojojutsu* are the tricks of binding up a captured opponent as a prisoner. Even further removed from what may be thought of as "martial art" are such arts as *senjojutsu,* the deployment of troops, *noroshijutsu,* the use of bonfires as signals during battle, and *chikujojutsu,* the science of fortifying a position.

All these forms of the bujutsu have been maintained, passed down, and conserved. Not for practical reasons, of course. They are a heritage bequeathed to those of the present capable of appreciating the insights they provide into the past. What this means—and this is the aspect of the martial jutsu most puzzling to those unacquainted with them—is that these classical systems are not easily available. Never intended for the masses in feudal Japan, the bujutsu were the exclusive province of the professional and hereditary warrior class, the bushi. The bushi disappeared with the twilight of feudalism in Japan. But the bujutsu did not, nor did the aura of aristocracy surrounding them. Today there are a good many painfully elite clubs with membership more easily acquired than is admittance to the average bujutsu system. Affiliation and tutelage comes usually only with the personal recommendation of one known to the elder masters of a particular bujutsu tradition.

Those jutsu of the warrior are, as the kanji implies, a long and twisting road, one to which the adherent must do just that: adhere. If he is fortunate enough to be admitted to such a tradition and can persevere at this extraordinary task of refilling the samurai's armor, the road will lead him to destinations of enormous value.

23 TE: HAND

手 The sword of the samurai attained its final and present form in the tenth century. It continued to find effective use as a tool of warfare until the 1860s. In ten centuries, the ideal shape and construction of the sword changed almost not at all. In the Occident, the principal weapon of combat, the firearm, underwent a phenomenal technical transformation from the time of its invention forward. From the crude wheel locks of the fifteenth century had come, by the twentieth, sophisticated guns capable of rapid, continuous fire and accuracy from amazing distances.

The difference in approaches to weaponry between Japan and the West is not merely technological. Confronted by limitations of effectiveness, the martial arts of the West responded with a continuous crafting of superior equipment. Confronted with similar limitations, the Japanese warrior responded by

fashioning a better self. The bushi turned not to technology in making his sword a better tool for fighting. Influenced by contemplative aspects of Taoism and Buddhism and by the self-discipline of Confucianism, he turned inward. He fine-tuned his body and his mind in order to better manipulate his sword.

The deemphasis of technology meant that the weapons of the Japanese martial arts, though of considerable quality, remain relatively simple. They are all hand-operated. Whether thrown, swung, or thrust, they all directly express, through his hands, the combative will of the user's mind. In some arts, such as sumo and Okinawan karate, the hands themselves become the instruments to kill or subdue.

The character for *hand,* or *te,* as it is spoken in Japanese, consists of only four linear strokes. These originated as a pictograph of an upraised palm and spread fingers. Simple as is its kanji representation, the hand is, of course, a tool of remarkable complexity. That it can be trained to accomplish such fearsome tasks as the bugeisha puts it to should never allow him to forget that making a fist or grasping a weapon are ultimately limiting. The greatest capacity of the bugeisha's hand is never in destruction. It is in its ability to heal, caress, comfort. The hand finds boundless potential in the *te* of *tegara,* "creative achievement."

24 KAMAE: POSTURES OF ENGAGEMENT

構 The modern martial Ways all feature *kamae,* postures of fighting engagement. In each of these, the exponent assumes a kamae designed to display strength and fighting spirit. In the kamae of the karate or judo practitioner, one can find not a single target readily vulnerable to attack. Likewise, the students of kendo and aikido study and practice to make their kamae impregnable.

Quite the contrary are the kamae of the classical arts of feudal Japan. In these ancient forms, kamae often display noticeable gaps, openings with a shoulder or a torso or the fists gripping the weapon exposed to danger. Looking at these postures, there is the temptation to imagine these warriors were suicidal, almost asking to be struck. In a way, the kamae of the older

arts *are* an invitation for attack. A bait. A deadly trap waits in these kamae, for the gaps of the postures in the classical arts are not an oversight in strategy; they are a deliberate part of strategy. The warrior's kamae induces an attack that he controls. By exposing a specific target, he knows from which direction the attack will come and can take advantage of it.

These contrasting uses of kamae reflect the distinctly different mind-sets of the twentieth-century bugeisha and his historical counterpart. Today's practitioner seeks to avoid violent conflict. He is defensive in attitude, fighting as a last measure to a threat and seeking principally to protect himself and others. The bushi's profession was in entering conflict. He had to be aggressive in battle, or at least he had to encourage an attack so the fight could commence. Self-protection was always secondary to the protection of the samurai's clan. His lord's interests came before his own. It is not coincidence, then, that the contrasting kamae of these different exponents in different ages would have their own uses and characteristics.

The kanji for kamae derives from two characters meaning "to construct with wood." A martial kamae is built, as well, in posture and in intent. The construction of the modern bugeisha's kamae may be said to be a solid fortress, designed to protect. The kamae of the classical bugeisha is more like a wier, woven to lure and then ensnare.

25 YOYU:
CRITICAL MARGIN

余裕 It is pertinent to ask, what is it that distinguishes the bugei from a combative form such as boxing or European fencing? The bugei's claims of dimensions philosophical and spiritual aside, what is it the nonpracticing observer might watch for that differentiates the martial Ways from the fighting to be found in every civilization throughout time? One characteristic element might be *yoyu,* the "critical interval."

Obviously, the complete conclusion of a bugei's technical goals lie in the destruction of another human. With the trained body alone the bugeisha can wreak disaster. When weapons are employed, the potential for calamity is even greater. It is an axiom of the Japanese martial disciplines that one has but a single opportunity in battle, that the contest is decided with one

attack that initiates success or spells defeat. For that reason, the utmost energies are exerted to demolish the enemy quickly, with all exigence.

Just as obviously, there is a paradox here. Even for the bugeisha of old, who may have cultivated his skills to reach fatal maturation on the battlefield, the restrictions of training necessitated some precautions for the safety of his fellow practitioners. The principal precaution then and now is yoyu, the margin the bugeisha leaves between his weapon in practice—a stick, sword, or fist—and its intended destination.

The mistake is to assume *yoyu* is Japanese for "pulling a punch." The error is understandable, but inaccurate. The calligrapher writes *yo* as a peaked roof over large crossbeams, evoking the notion of "ample" or "plenty." *Yu,* a literary allusion, means "clothing roomy enough to cover a valley." The narrow interval between the attack and the target is expressed, then, by two kanji, both representing the expansive and commodious, a clue to the meaning of *yoyu.* By contracting the space he maintains separating destruction from preservation, the bugeisha expands his control over the moment itself. The more narrow the gap, the wider the options for changing the direction or manner of his attack—a valuable asset in a fight. Through the development of yoyu, the bugeisha's control permits him freedom to alter his strategy at a hairsbreadth. The technical control of his self through yoyu enlarges vastly his ability to control the whole of the situation.

In the age of the samurai were swordsmen who, placing a cooked grain of rice on the forehead of a (brave) volunteer, could with a full stroke stop their blade, cutting the rice and leaving the forehead unblemished. The command of yoyu at such a level is almost never equaled by today's exponent. Still, the development of yoyu is a primary technical aim of the bugeisha. His proficiency in it is an unmistakable characteristic that marks all his fighting arts.

26 HARA: THE CENTER

腹 Moments of utter sincerity call for the Westerner to "open his heart." A Japanese in the same situation "opens his belly." At one time this expression was, in a sense, more gruesomely literal than figurative, for "belly cutting" is, of course, the translation of *hara kiri,* the visceral immolation that was in the era of the bushi the ultimate expiation of guilt, the most eloquent utterance of outrage, the final act of loyalty.

The calligraphic interpretation for *hara* is a "swelling of the body." To trace the kanji for "swollen" back even further reveals an older meaning: "container." The *hara* is a container of a corporeal as well as an emotional sort. (Though it is not, incidentally, for food; *hara* is linguistically distinct from the anatomical term in Japanese for *stomach*). What the hara contains is the center of the self.

The ideal somatype of the heroic Japanese is that of the *riki-*

shi, the sumo grappler who, with his thick legs, sloping shoulders, and massive middle, is something like a human pyramid. He moves and acts, as do all bugeisha and all exponents of Japanese arts, from his hips, his hara, for it is the universal foundation of locomotion for all of these arts. His success in the ring will depend upon his ability to keep his body center under him and to command that of his opponent. In a sense, all Japanese martial Ways are grounded in this rudiment, and so each respects the hara.

The bugeisha manifests his strength from his hara. Watched closely, his body dynamic, from the greatest to the smallest and most subtle, will be seen to originate at this center of his body. For that reason, much of the bugeisha's training is designed to exploit the strength of the hips and waist. He engages in *shikko,* a method initially tedious and painful (though not injurious if correctly done) of walking on the knees. The same attacks and defenses he learns standing he also practices crouching or seated on the floor. As a result, his waist becomes supple, his belly firm and strong.

Specifically, the bugeisha sinks his awareness of balance, breath control, and gravity to a spot inches directly below his navel. This is his center of self. That the largest musculature of the body surrounds the hara, that coordinated motion is best accomplished using it as a fulcrum—these reinforce a deeper idea: the consideration of the hara as a residence of the soul and the emotional nexus of the self. "I hate his guts," "I vented my spleen,"—such idioms remind us that cultures other than Japan's accord an emotional affinity to the abdominal region. In Japan, however, hara incorporates an emotional aspect as an idea and goes a good deal beyond.

In Japanese thought, the hara is a medium of a kind of communication, a nonverbal transmitter and receiver of infinite tuning. The hara communicates feelings, motivations, intent.

It is the radio and radar of the bugeisha. He *thinks* from his hara, absorbs incoming information there, and is capable in certain situations of influencing others with it. Strange? Yes. But not completely unfamiliar to a West that understands "gut" feelings as well as the act of confessionally spilling them.

The hara may be thought of as a container for a range of conduits. For the bugeisha and others of his persuasion, the hara conducts sentiments, mental attitudes, and physiological vitality. It is the center, in a great many ways, of a great many things.

27 UKE: RECEIVING

受 When the conversation leads to the subject of toughness, as inevitably it will among young men and women in transit on the Way, opinions will flow liberally. This master, it will be recounted, knocked an opponent senseless with the briefest riposte. That one, someone will say, uprooted young trees with his bare hands. Still another will be said to crush stalks of green bamboo with his. Comparative feats of strength are presented as proof of toughness in these conversations, especially those among younger bugeisha. The more senior exponent, however, tends to have a different way of measuring toughness. With experience comes, too, the knowledge that toughness is less a matter of dishing it out and is really more in the ability to receive.

Uke is a pictographic kanji, one written to depict two hands, one reaching down, the other stretching up, and between them

is placed the character for "boat." This "conveyance of goods from one person to another" became, over the centuries, the kanji to indicate the act of "receiving." The bugeisha uses the word frequently. In the grappling bugei, the methods of falling safely are collectively called *ukemi,* the "receiving body." In judo terminology, the exponent thrown is *uke,* the "receiver." Of the pair in karate practice, the one under attack is the *ukete,* the "receiving hand." In kendo, the defender is the *ukedachi,* the "receiving sword."

In these and other expressions in the bugei lexicon, the importance of the term *uke* is significant. It is commonly mistranslated in judo circles as the "taker" of a technique. Uke is thrown and so is considered the "loser" in this way of thinking. To understand that *uke* means more exactly "to receive" opens new views for the practitioner. To be on the uke end of training is not to be passively accepting of the technique. It is instead the attitude of receiving, meeting the throw on one's own terms. The mentality of the uke is not one of resignation or, worse yet, of stubborn resistance. The uke flows, absorbs the force of the throw, and while he does fall, his ukemi does not necessarily signal defeat. His fall is one he controls. He receives—and bounces up again.

The terms *ukete* in karate and *ukedachi* in kendo are subject to a similarly misleading translation. Here they are thought of incorrectly as designating the participant who "blocks" an attack. Not so. The *ukekata,* or "receiving forms," of kendo and karate require a receiving of the incoming force in order to redirect it away or to use it to come back against the attacker.

In the mature training hall will be very senior bugeisha, older men and women, and they can be seen happily taking falls or blows, over and over, from children trainees. Against adolescent members, young and full of themselves, the seniors will be just as complacent, mildly taking all the excess energy of

youth without a bruise or wince, until, among the brighter of the youngsters, will come the realization that there is something more to all this activity than it seems. They will, some of them, begin to suspect that the toughness of these older bugeisha is a thing yet to be discovered out there along the Way. They will have begun to see the true toughness of receiving.

28 KYU: RANKS OF THE BEGINNER

級 Once set out upon the Way, the bugeisha may wonder at times if he is becoming entangled in an enormous web. All around him are threads, some inviting him to pull upon them, to unravel them and see where they lead; others seem to entangle him hopelessly.

Attractive threads that tempt him to follow are, for example, those techniques that fascinate the bugeisha and show a promise of some wider implementation than the ones he currently knows. So he tugs: he presses his master for further instruction in the technique or tries to demonstrate that he knows what has been taught well enough to warrant being taught more. At that moment the master steps in and introduces another thread, this one to trip up and bind the bugeisha. Convincingly, he

shows that the technique is not so well understood by the bu-
geisha as he thought.

Some threads appear to be woven into the bugei deliberately
to hamper and restrict the bugeisha. The rules of the training
hall, the intricate terminology, the very tediousness of the
process of training—all are restrictive to the follower of the
Way eager to be free to get on with the journey. At other times,
especially as he continues on, the bugeisha may begin to see
threads that can assist him, threads that provide answers to
problems or give support. The bugeisha comes to understand
that the threads, all of them, are intertwined to make the fabric
of the bugei.

Most modern bugei forms denote a series of rankings within
their teachings, sometimes signified by colored belts, to mea-
sure outwardly the inner progress of the beginning trainee.
These are the *kyu* grades, the levels of the beginner. *Kyu* is a
composite kanji. It combines the strokes for "thread" with
those meaning "joining together." For the bugeisha trying to
make sense of all the strands that surround him, the character
is most appropriate.

29 TAN: FORGING

鍛 On the battlefield, in duels, and in other life-and-death confrontations, the warrior of old was understandably concerned with winning and losing. His life depended—or ended—on these matters. The bugeisha today values the distinctions of victory and defeat in his contests and in situations where his skills are put to the test against aggression. Yet aside from these infrequent instances, the subject of determining winners and losers is rarely of consequence in the bugei. It may appear preposterous that arts of fighting would be unconcerned with distinctions between those who prevail in a struggle and those who are vanquished. However, it is a very different struggle in which the bugeisha is engaged.

Many words describe the process of training to which the bugeisha submits himself. One is *tanren*. *Tan* and *ren* mean essentially the same thing. From *ren* comes, among other bugei-

related terms, *renchusei*, "trainee," and *renbu*, "training organization." From *tan* comes *tandoku*, "solo training." *Tan* has an informative etymology. It comes from a combination of strokes meaning "metal" and "to tread down" or "to beat." In other words, the intent of "training" in the bugei is to "forge."

The bugeisha's real opponent is himself. This is true of many disciplines, admittedly. But the bugeisha's challenge is special. Like the mountain climber, he must face down his own fears. Like the long-distance runner, the bugeisha fights mental and physical fatigue in a solitary way. The climber, though, scales his peak, or fails. The runner wins the race, or he does not. The bugeisha has no such milestones to reckon by. His conquests in competitions are, he knows, ephemeral accomplishments. Advancements in rank may measure progress in the acquisition of technical skills, but skills alone will not lead to a mastery of the Way. Success in the martial Ways can be figured, if at all, by other standards, by the reputation of the bugeisha and his standing among his peers. For himself, victory is not a final product that means anything. It is the process that matters. The forging. Tanren.

30 GEI: THE CULTIVATION OF CRAFT

Bugei is a convenient, comprehensive term to describe the martial arts of Japan. Both those military arts maintained by the classical warrior and those practiced by the modern exponent may accurately be called by this word. The kanji *gei* juxtaposes the radical for "plant" with a pictograph of a person kneeling to tend it. "To cultivate," not just in the horticultural sense but in an artistic or utilitarian way, too—*gei* has wide use in Japanese. There is the familiar *geisha*, which refers to a *sha* (person) skilled in the gei, or arts, of entertainment. *Mingei* are the gei of the *min*, or "common people," that is, "folk art."

Under the canopy of the term *bugei* is a broad range of combative arts. From the feudal age comes the expression *bugei juhappo*, "the eighteen martial arts," a phrase that led some

scholars to try to categorize all Japan's warrior disciplines in less than twenty forms. It is an impossible task. Medieval Japan, with its protracted period of civil war that gave rise to the samurai class, was a remarkably fertile ground for the cultivation of martial arts. The expression is purely figurative. In fact, there are at least fifty distinct forms of bugei, some now extinct, some rare, some flourishing.

Westerners know best the modern bugei, most of which favor the suffix *do,* or "Way," to distinguish them from older classical forms. All the modern bugei are twentieth-century creations; nevertheless, all are constructed around a solid foundation of thought so traditional it can, to the uninitiated, appear decidedly idealistic. The modern bugei are Taoist in their guiding inspiration, devoted to the idea that man can and should seek a life in harmony with environmental forces, a life devoid of affectation or pretense. Confucianism invigorates their methods and manner of teaching with its recognition of place and the obligations of those above and below one, a preference for learning by *doing,* and a core system of values based upon a balance of social virtue and self-awareness. In their aesthetics, the pursuit of beautiful form within the context of practical substance, the modern bugei are profoundly, completely Japanese.

Outside their native area of cultivation, and increasingly even within it as Japan continues to adopt Japanese perspectives, is the treatment of the modern bugei as a means of self-defense. The notion amuses their serious exponents. It concerns them, as well. It is amusing because the image of fists, swords, or sticks arrayed against the automatic armament of today's urban predator is tragically comic. That the bugei would be considered primarily as a means of self-defense is a matter of concern because to engage in these disciplines simply to fight is to seriously distort them. In extreme circumstances,

the techniques of the modern bugei may secure an individual's safety. To follow them as a Way, though, with these goals of self-protection in mind, is a sure formula for frustration. The modern bugei are, despite their outer form, decidedly not designed for practical combat, either in a military or a civil sense. The summit of these Ways is attainable through a sincere quest for cultivation of the inner self and through a devotion to the furtherance of social virtue.

Judo, kendo, aikido—these are the most "purely" Japanese of the modern bugei. There is also, of course, karate-do, a discipline as popular in Japan as the other three but more difficult to classify. Unlike the others, it is not descended from a feudal-age martial form. It is Okinawan in origin, an art of peasants rather than professional men-at-arms, and so in the hierarchy of the modern bugei it is often like a distant relative: family to be sure, yet not easy to place.

Other modern bugei forms that are practiced slightly less widely include *iaido,* the art of swiftly unsheathing and cutting with the sword, and *kyudo,* or archery. Rarer and more esoteric are *naginata-do,* the Way of the long halberd, and *jukendo,* the use of the bayonet, which is followed as a martial Way both by Japan's Self-defense Forces and by some civilians.

The diversity of the modern bugei is a testament to Japan's martial history. It is also an example of the creative and ingenious spirit of those who seek forms by which to cultivate themselves.

31 KAGE: SHADOW

影 Two bugeisha: One, a young Japanese-American already enduring the hardships of a World War II internment camp, witnesses the fatal beating of a friend by military guards, who force him and others secretly to bury the body. In Japan during the forties, at nearly the same time, another bugeisha watches helplessly as fellow high school students bludgeon to death a teacher after the man breaks the news that Japan has—unthinkably—lost the war.

These are matters of *kage,* the shadows that color the personality of the mature bugeisha. It need not be so dramatic as murder. The kage are in the suffering and tragedy that are the lot of life for all of us. The bugeisha is no more immune to grief or anguish than anyone else. He distinguishes himself, though, in his reaction to these inevitable events.

The bugeisha does not allow catastrophe or misfortune to

brutalize him, to enervate his emotions. Nor does he permit these to scar his soul and leave him cowering and intimidated by life. His Way is the product of a culture imbued with Buddhist fatalism. The Way encourages him to accept the presence of calamity. Because his path is one he knows has been trod successfully and meaningfully by others before him, he has confidence in his ability to accommodate adversity, if not to overcome it. The agonies and torments, the tribulation and despair life sometimes provides, the bugeisha accepts. They are a part of his memories, a part of him. They are the shadows, the kage that give depth and delineation to his personality.

Kage is composed of a very old kanji character aligning the strokes for "sun" over those for "capital." Etymologically, the combination begats "bright." Three short slanting strokes complete the character of *kage,* denoting a grid through which the sun's rays pass. *Kage,* then, is derived as a written form from the patterns of dark that describe the brightness, that give it balance.

The Japanese–American internee has become a highly accomplished kendo master and is a professional potter in the folk tradition of his ancestors. The high school student is an economist and a karate practitioner of international repute. Their accomplishments glow brightly. But of their characters, how much has been defined by that which is in the shadows of their past, concealed in the kage?

32 ZAN: LINGERING

残 *Zansetsu* is the snow that resists spring, melting slowly in the shaded lees of the hills. *Zansho* refers to the heat that hangs on into early autumn, reluctantly loosening its humid grip to the cool fingers of frost that finally spread across the land. The gaze of the bugeisha in the midst of confrontation is as cold as snow, while penetrating with a heated intensity. It is a manifestation of his *zanshin*.

Zan has a fascinating derivation as a kanji. Its radical, on the left side of the character, is that of "bare bones." Other strokes depict a pair of halberds. The implication is martial, one of cutting until nothing is left but the bones. *Zan* has come to mean "to disintegrate," "to be extinguished," but to do so gradually, like coals giving up the heat within as they cool to ash. Zanshin, the "spirit that lingers on," is an inevitable characteristic of the more experienced bugeisha. He exhibits it in

the most chaotic moments of battle as well as in the periods of his life that are perfectly peaceful.

The concept of zanshin is a complex one, integrating physical presence, technical skill, and emotional attitude. Vigilant calm. Action in repose. Mentally, zanshin is the quality of diffusion, a steadfast awareness of all that transpires without focusing on, and so being distracted by, any one phenomenon. Bodily, zanshin is expressed through a posture that is relaxed yet resonant with potential power. When an accomplished bugeisha moves decisively, his technique appears to vibrate past the conclusion of the action. Facing multiple opponents, his concentration is never arrested by one of the many. Both these occurrences reveal a state of advanced zanshin.

The beginner is apt to mistake a fierce grimace and a stance of rigid aggression for zanshin. But such artifice is only a caricature that cannot be maintained for very long. It is too exhausting an effort, and it misses the point. True zanshin, developed over a lengthy period of rigorous training, is never so concentrated a force. It is not a tsunami, a single wave expended at one place in one moment and then gone. Zanshin is like a great ocean, bottomless and alive with latent, surging energy. Like the rhythmic pounding of its surf, which echoes beyond the range of its actual sound, the force of zanshin lingers on.

33 SHA: THE EXPONENT

者 The fact that some kanji are pictographic in derivation does not mean, as might be assumed, that simply by unraveling them back to their origins we may divine the present meaning of the character. Some kanji have evolved to be, in current usage, quite different from their historical form. In other instances, the semantic tale a kanji tells can lead us to wonder if there was within the embryo of the kanji's original inspiration a message, one carried down through the centuries for us to discover today.

A person who follows the path of the marital Ways, the bugei, is called a bugeisha. *Sha* is a compound kanji. One combination of strokes stands for the joining of "fire" with "combustible materials," the "kindling" necessary to sustain a flame. Below that is brushed a square "box" for containing these materials of fire-building, and the result is *sha*. That "per-

son" in calligraphic form would be expressed as a box for holding useful things is curious. Later on, however, the first strokes came to mean not just "useful materials" but ordinary "odds and ends," and the connotation—that we as humans are scarcely more than temporary storage places for the bits and pieces we collect during our stay on the planet—was a less than complimentary term for a person.

Today, of course, the average kanji reader merely recognizes the character for *sha* when he reads it and never gives a thought to the etymology. The bugeisha, accustomed as he is to pursuing the obscure and the ancient, might return to the source of the kanji for *sha* as an opportunity for self-reflection. What are the materials with which he fills his "box"? Necessities for a worthwhile life? Or trivial odds and ends?

34 MYO: THE MIRACULOUS

妙 The bugeisha makes a thousand repetitions of technique in his training. Then a hundred thousand. Possibly it is the most elementary of techniques—an overhead strike with the sword, for instance, meant to cleave vertically—and he is certain he has plumbed its depths. Then he sees his master perform it, just once perhaps, and his certainty vanishes. The master imparts something to the cut, personalizes it and lifts it in a single execution into a performance wondrous and fascinating to the bugeisha who witnesses it.

This special something that makes a technique unique and elevates it beyond simple mechanics and into the realm of high art is called *myo*. Myo is a phenomenon "miraculous" or "marvelous," as the word might be translated, but one that to the ordinary consciousness appears just the opposite. A toddler stumbling tentatively across the floor is clumsy and cute to

those uninvolved with the child. To his parents, such a moment is replete with the wonder of life itself. Events such as the changing of the leaves in the fall are understandable from a scientific point of view and barely noticeable to most who drive along tree-lined streets each September. To those who take the time to truly see these changes, from the moment the green begins to fade until the leaves finally loose and fall from the branch, autumn is a time of wonder. It is a thing of myo.

The bugeisha's myo is no different. His techniques, perfected through endless practice, acquire a special aura. The nonpractitioner might not be able to detect it, may see nothing out of the ordinary. Those sensitive to the myo arising from expertise will recognize its presence instantly.

The difficulty in expressing the quality of myo in words is exemplified by the character used to write it, constructed of a pair of pictographs that together mean "a small, delicate woman." The implication is obvious. Just as a woman's grace and beauty can captivate and intrigue in the most inexplicable ways, so it is with all that is myo: marvelous beyond expression, wonderful to behold.

35 REI: ETIQUETTE

礼 At the outset of his pursuit of the Way, the aspiring bu-geisha may worry that the journey might compromise some of his religious convictions. When he begins to actually travel on the Way, he may wonder if, in fact, there are any religious dimensions at all on this path. Little that could be classified as religious instruction is forthcoming from his master, and this confuses him. The bugeisha at this point has not yet learned the distinction, inherent in all Japanese Ways, between religion and spirituality. The Way is unattached to particular religious dogma. More accurately, it could be said to provide a more meaningful access to any of them. It demands, though, a devotion to spirituality, and this devotion makes itself evident, in part, in the form of etiquette, or *rei*.

The bushi developed an intricate and extensive catalogue of etiquette during the medieval period. His etiquette was a neces-

sity in dealing with the frictions that could be generated during the social intercourse of fighting men. He had carefully prescribed methods for entering a room, for taking off or donning his sword in the presence of others, even for standing or sitting. All these were performed so as not to appear aggressive and therefore a threat to those around him. The warrior's etiquette also acted as a form of protection, allowing him to move and interact with others without exposing himself to danger. Classical systems of martial art incorporated these standards of etiquette into their curriculum. All samurai knew and practiced them. It is actually possible to identify a particular system of martial tradition, in fact, just by watching the etiquette displayed.

More fundamentally, rei is an integral part of the consciousness of all traditional Japanese culture. It springs from the very basic concept that if the outer form is correct and proper, a similarly condign impulse will follow. If the shadow is right, the pattern creating it will be right as well. Comparing this to modern Western perceptions reveals an abrupt contrast. The latter insists that conscientious sentiments lead naturally to a propriety of manners and actions. In Western modes of instruction in writing or art, the student's inspiration and creativity are stimulated initially. Only later is he tutored in the forms of grammar, perspective, and so on. The Japanese paradigm pursues the opposite course. This is clearly evident in the Japanese approach to rei: impart a standard, provide the model, and expect it to be filled with a suitable disposition.

In a culture like Japan's, which venerates outward impassivity and stoic composure, etiquette, once mastered in form, becomes in content a means of self-control and a way of sheltering the spirit. Rei is a matter of presence. It is the style of graciousness. It is the containment of the emotions. Inwardly, the bugeisha may rage or rejoice. But, in the outer

form of rei, there are no clues of this, and so an enemy is deprived of the advantage of reading the bugeisha's behavior. The bugeisha's companions, unless they are intimate and therefore capable of seeing through the form in subtle ways, are spared the task of unduly invading their friend's sense of privacy.

Rei is vital to the bugeisha for very practical reasons. His training hall is a dangerous place. To have rigidly prescribed forms for exchanging weapons, sitting, or moving about—all contribute to a less hazardous, more secure environment. Beyond that, rei offers to the bugeisha a form, a framework, to support and protect and, yes, to insulate, at times, his soul. The calligrapher constructs *rei* by brushing pictographically a man kneeling at the altar. This is fitting. Rei teaches the bugeisha *how* to sit before the altar. It leaves up to him what it is he shall worship there.

36 MA: SPACE

間 A typical brush and ink painting in the Japanese sumi-e tradition will have perhaps a single gnarled plum branch in winter and a line or two of verse, both set off to one side of the composition. On the other side will likely be an expanse of empty white space. To the aesthete, it is this blank area that excites the imagination with possibilities, that makes the work of art alive and interesting. What is *not* there is as important to the whole painting as what is. The *ma,* as such space is called, animates the bugei in the same way. The distance between opponents is alive with possibilities for attack and defense. Learning to close the ma in order to reach his target is a crucial lesson to be learned by the bugeisha. So is the matter of maintaining, when necessary, a ma of safe distance.

There are essentially three variables of ma to be found in the training hall, no matter what particular bugei is being practiced

there. Each of them has a basis in swordsmanship. *Toi-ma* is a "long space," with considerable distance between opponents. The wide space in toi-ma is such that no attack can be launched, no defense is necessary. *Itto issoku no ma* is a ma where a single step (*issoku*) by either participant will bring them both into range of the other. It is at this distance, the tips of their swords separated by a finger's length, that fencers maneuver and feel one another out. At *chikai-ma,* "close distance," weapons have crossed. The outcome of the battle will have been decided. Toi-ma is initiatory. Itto issoku no ma is engagement. Chikai-ma is decisive.

Ma is written by combining two kanji: the "sun" shining through a pair of "gates." And yet, more poetically, we can imagine two warriors locked into the ma of the battlefield, etched against the horizon, with a sun between them that neither may live to see set again.

37 KU: EMPTINESS

空 From the Buddhist sutra, the *Hannya shingyo,* comes a phrase that expresses the essence of the bugeisha's training: *shiki soku ze ku, ku soku ze shiki,* "from form comes emptiness, from emptiness comes form." *Shiki,* as it is used in the *Hannya shingyo,* or "Heart Sutra," renders into English as "observable form." But to translate the word *ku* as "emptiness" is incomplete. The implications of ku defy such a simple equivalent.

The pictographic origins of the kanji for *ku* lie in the depiction of a "roof" and another ideograph meaning "to open up." The brush strokes for the roof remind us of the huge timbers and wide gables that make up the thatched roofs of the *minka,* the rural Japanese folk house. Surely, the peoples who lived under the open sky or in natural shelters must have regarded the immensity of the heavens with a kind of spiritual awe. But

the man who has constructed his home, who lives under a roof, like that of the minka, that he has built, looks at the sky in a different way. The roof is a physical reminder of his distance from nature. It affords him, as well, the luxury of contemplating nature and the universe in comfort and safety.

The roofline of the Japanese country house is broken by gables that serve as ventilation. From inside the attic, the owner could look out at the sky framed by these gables and be reminded that, for all his architectural accomplishments, the roof of the sky above him would forever keep his place in the universe in the proper perspective.

One of the most challenging formal exercises of the bugei of karate is called *Kanku,* which means "to perceive the ku." Kanku's distinctive opening movements simultaneously lift the practitioner's gaze and hands in such a way that his hands frame the sky between them in a triangular shape exactly like that of the farmer's open gables. This may be the surest path to understanding the concept of ku: to contemplate the soaring expanse of the sky, the infinity of space around us.

Ku is the void of the universe just before the creation of planets and stars, an "emptiness" not in the negative connotation of that word but with the implication of potential. Ku is a kind of tabula rasa of cosmic proportions, yet it can be detected in an individual human being. When he enters the training hall, for instance, the beginning bugeisha has the quality of ku. He is an empty receptacle, his responses to the most basic of attacks completely untutored. Through training, he acquires skills. His abilities crystallize into recognizable patterns. Faced with familiar methods of attack, his replies grow standardized and competent. His ku has metamorphosed into shiki, or form.

The less assiduously tempered bugeisha may believe his journey along the Way is complete when he has found shiki. Those mindful of the teaching of the Heart Sutra, though, will realize

that "emptiness becomes form" is only one half of the complete phrase. They push on. Through unflinching adherence to the master's instruction, the serious bugeisha actually transcends the techniques of his bugei. His responses to attacks of any kind achieve a flowing spontaneity that is alive and vibrant. There is no prior thought necessary, no calculation, yet even so, his actions have about them a magnificent celerity and deadly acumen. His form has become formless. The bugeisha at this stage has returned to the beginning, to the great void of ku.

38 FURYU: WIND AND WATER

風流 A red maple leaf, wind-tumbled loose, drifts in the air, then plops into a clear pool, spreading rings around it. . . .

In every age, man has sought beauty in the examples of nature. Medieval Japan was no exception. In times of peace, the search for such beauty can be difficult enough. In the turmoil of war that Japan knew through much of the feudal period, it was a task requiring an extreme diligence. The sense of beauty that emerges from such conditions is apt to be greatly influenced by those conditions, as well. In Japan during the age of the bushi, what arose was *furyu,* the beauty of wind and water.

During the long, peaceful Heian age, ca. 800–1200 CE, there blossomed a romantic taste in art rich in ornamentation and

color. It was an art of brocade and ostentation and the elegance of the noble classes. Yet even in the splendor of Heian extravagance ran a deeper current in Japan, an artistic suggestion that beneath the grandeur of court life was a more transcendental reality. Best described by a term from that age, *miyabi,* it was a notion that both life and art were brief, fleeting. Miyabi suggested that an ultimate beauty could be found in the recognition and connoisseurship of the ephemeral.

Tapped in the Heian period, the spring of miyabi was brought to full aesthetic flux during the violent epoch of the samurai, where it flowed in a deep stream and was recognized as furyu. *Fu* (wind) and *ryu* (water) is an acknowledgment of the autumnal, although its appreciation is hardly limited to that season. In spring, the bushi was drawn to the iris, with its swordlike leaves and blooms that lasted only a few days. Moon viewing in summer, in winter, a flask of warm sake savored during a midnight's snowfall—all were opportunities to contemplate fragility. Even in the most enduring objects the warrior could find furyu. Mossy granite boulders and the raked gravel seas of Zen-inspired gardens were reminders to him not of permanence but of how brief was life measured against the timeless.

Furyu is a resignation to that which the drifting leaves of autumn imply. It is an immersion of the spirit in the finitude of cherry blossoms scattered on the breeze. The word itself suggests an intensity of emotion too sharp to be verbalized or even intellectualized. Furyu is experienced as a kind of aesthetic pathos. It is a harmonious sympathy with the fluctuations of the natural world.

In contrast to many other aspects of Japanese culture, there appears to be no Chinese model from which the Japanese drew their inspiration for furyu. It is a concept of beauty authored entirely by the medieval Japanese. Without doubt, the samurai

class was a major influence in the blossoming of furyu as an ideal. Men-at-arms are given to one of two courses in life. The first is toward the brutal, the coarse, the vulgar. It is certain that the bushi had among his number those who chose this path, those who responded to the constant precariousness of their profession by grasping at pleasures that allowed them a momentary dulling of reality. Others chose to see in the fragility of life a delicate, poignant beauty. For them, the beauty of the Way is expressed in the evanescence of the seasons, the fleeting, the mutability of wind and water—furyu.

39 I: INTENT

意 "Cut my skin," goes an epigram of the bushi, "and I cut your flesh. Cut my flesh, and I cut your bones. Cut my bones, and I kill you."

No matter what the level of conflict, the warrior of classical Japan was prepared to escalate it one degree beyond in order to achieve his aims. He was prepared not only physically and technically but mentally, as well. This firmness of objective is called *i* in Japanese. "A resonance of the mind" is how the calligrapher composes the word, placing the compound for "sound" above the radical for "mind." I is a resolute determination, a commitment to a course of action.

When he has progressed far enough to begin serving as a practice partner to his juniors, the bugeisha is susceptible to err in this role in two ways. As a senior, it is his task to attack or otherwise press his junior in order to elicit the desired response.

He is instructed by the master to make his attack realistic. If his actions are not vigorous, the bugeisha is told, his junior will never be stimulated to respond properly, with full spirit and effort. So, motivated perhaps just a bit, too, by his ego to show the junior how far he has come, how well he has learned, the more senior bugeisha unleashes a full-force explosion of an attack. It is, of course, altogether too much for the junior, who is struggling merely to memorize the mechanics of his response, never mind being able to perform it against such energetic opposition.

The master must intercede here, lest the junior become completely dispirited and overwhelmed. He admonishes his more senior disciple to gear his actions more appropriately to the junior's capabilities. So the senior steps in again and takes an approach that is completely different from his initial one and just as completely wrong. His motions are now flaccid. The junior, even at his level, senses immediately that there is no danger, no threat, and so his movements quickly become sluggish and imprecise.

Again the master steps in. He demonstrates, attacking with a fraction of his strength and speed but with 100 percent of his i. His bearing and composure are such that he communicates instantly his complete will to connect his weapon to the target. The junior reacts. He now has the opportunity to move correctly, but he is still under pressure. He is forced to contend with the master's i. Through such encounters, the bugeisha is introduced to the mental component of commitment. To be more exact, he learns an elemental truth, one expressed in the composition for the kanji of *i*: commitment is a resonance of the earnest mind.

While not divorced entirely from technical competence, i, as its kanji indicates, is primarily a function of the will. The pacifist, for example, strives to generate an i directed undividedly

toward noncontention. The i of the bugeisha, a coordination of intellect and inclination, is not necessarily one of a unanimously aggressive bent. It may manifest itself, as circumstances dictate, in complete passivity or in the most extreme of actions. I is unquenchable resolution, the determination to follow through. No matter what he undertakes, i is what makes of the bugeisha a most formidable person, and it is a quality that will take many years for him to perfect. No matter. Having seen i in the personality of his master, the bugeisha is determined to develop it as a part of his own character. Such a determination is often the bugeisha's first conscious act of i.

40 SHUGYO: AUSTERITY

修行 Too early in the morning? Get up and train. Cold and wet outside? Go train. Tired? Weary of the whole journey and longing just for a moment to stop and rest? Train. Continue on in the spirit of perseverance—this is the advice for the bugeisha who reaches an obstacle in the Way, as surely he will. It is advice that will be lost on the novice. The beginner's enthusiasm is such that he cannot imagine what blocks could lie ahead to halt his progress. If some decisive challenge to his continuing on *does* appear at this early stage, he will likely abandon his practice altogether. The art has not yet penetrated into his daily life. It can be quit without damage to the psyche. It is the more advanced bugeisha who must face dilemmas and potential obstructions that can have serious emotional and psychological consequences. It is *shugyo* to which he must turn at these times if he expects to overcome and persevere.

In most physical pursuits the newcomer's acquisition of skill accelerates rapidly. Eventually, a plateau in learning is reached, a relatively short one that will, with little effort, be surmounted. As he continues, the practitioner periodically encounters plateaus that are longer and longer. Progress becomes harder to judge. At this point, when the activity is a hobby or pastime, the participant can convince himself that further polishing is unnecessary. He may be content to remain where he is, performing at a constant level. Or he may cease the activity entirely and find another. The bugeisha experiences the same swift start, the same plateaus, the same periods without progress. But the bugei are not a pastime, and the options for the bugeisha when those difficulties arise are not so simple.

Eventually, no matter how enthusiastic and determined, the bugeisha has doubts. Why is he spending so much time at this odd enterprise that has no practical value and offers no tangible reward? He may be encouraged by friends to give up this silly venture, to find something more conventional to do with his time. Injuries, almost inevitable, will also tempt him to terminate his journey on the Way. Boredom dulls his concentration. He is tormented finally, as self-doubts and questions about the worth of the whole undertaking consume him. There is every reason to quit and apparently none at all to continue. The model set by the master seems unattainable. Further, appealing for solace or for answers from his teacher are now met with a brusque, familiar reply: train.

On the outside, the master is indifferent to the plight of the bugeisha at this stage. Inside, he is keenly attentive. He watches to see if the student can pull from the center of his being the motivation to continue. The master knows that if the bugeisha lacks sufficient self-actuation, he will not persist in finding the Way. Much as the master may care for his disciple, he cannot

bring the bugeisha through this crisis of agony and con-
foundment.

If the bugeisha endures, he finds himself entering onto a new
horizon. He will have ascended to the elevation of the Way
called shugyo. *Gyo* is a modified pictograph of a "crossroads."
Shu is a more complex character. It is written with deft, quick
dashes indicating "delicate hairs" like those of the calligra-
pher's brush. Other strokes making up *shu* act to express "a
hand grasping a stick." In normal parlance *shu* means "to prac-
tice" or "engage in study," though etymologically it is "to
strike with delicate precision."

The bugeisha at the shugyo level of training finds himself at
a mountainous crossroads. It has dawned upon him that the
bugei are enormously difficult. He has progressed far enough,
too, to realize they promise rewards he can discover nowhere
else. He may wish to quit, but if he forges ahead into shugyo,
he cannot. He has passed the crossroads. His training remains
directed at a perfection of outer form, but after entering shu-
gyo, the development of the inner person has become para-
mount in his daily practice. The bugeisha involved in shugyo
now strikes more exactly, with more deliberate and delicate
precision, because his target has become the self.

Shugyo is thought of as austere training or as the training
process of the anchorite. More positively, it is the path taken
by the bugeisha to overcome barriers. It is arduous. Shugyo is
trying and exacting and will not let him rest. And once he has
passed the crossroads, it is the only means by which to proceed
on the Way.

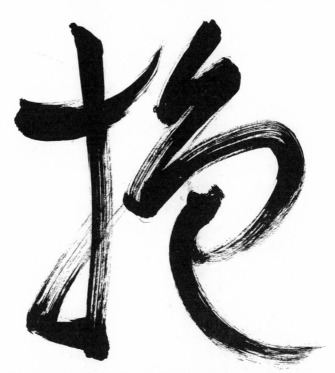

41 HODOKU: COMPASSION

施 Much has been made of the cruel arrogance of the samurai class and of their privilege, a legally condoned one, of cutting down any commoner who behaved discourteously toward them. Some victims fell to the samurai's blade, tales have it, for no reason other than the warrior's desire to test his technique. Such horrible accounts are not entirely the stuff of legend. Outrages did occur. But they were not an everyday event in feudal Japan. Curiously, the very arrogance of his class imbued the samurai with a strange kind of compassion that seems quite odd by modern standards but that was nonetheless geniune and was a central component of the warrior's character.

The cultural inheritance, breeding, and education of the Japanese military class all reinforced what he believed was the innate superiority of his caste. This belief was a matter of fact to

him. Space travel would have been a more plausible notion to
the samurai than egalitarianism, and with this mentality came
a sense of patronization to those not of his rank. The attitude
is not difficult to understand. The commoner, after all, did not
risk his life in battle. Those not of the warrior class did not live
with the burdens of duty. They were not required to acknowl-
edge guilt or responsibility by disembowelment. (Of course,
the samurai understood little of the demands of taxation, of
poor crops, and the other daily woes of the common folk.) To
the bushi, those without such status and concerns could
scarcely have been regarded as equals. The other classes were
to him more like children. And just as a normal adult would
not injure a child over the child's insult or rude behavior, the
warrior who used his weapon to cut down a commoner would
have been subject to scorn and ridicule among his peers.

The bushi felt, if not a responsibility for those below him on
the social scale, at least an indulgence that in a feudalistic sense
may be thought of as compassion. And while the sentiments
he engendered for the lower classes were hardly what we might
call humanitarian, they did frequently stay his hand from the
murderous excesses of which later historians have accused him.

In relationships with others of his class, the bushi exhibited
a different kind of compassion, one no less difficult to under-
stand from our perspective. Wounded in battle, a warrior
might request a foe to dispatch him, and out of compassion,
the opponent would comply, saving the wounded bushi the hu-
miliation of capture. Entire families of a defeated clan might
request assistance from the victor in committing suicide, and
in the same spirit of compassion, their enemies would provide
a swordsman to behead them to finish their agonies and to
spare them a life of shame.

Compassion in the Christian sense was not unknown in feu-
dal Japan. Imported by Jesuit missionaries as early as the six-

teenth century, the faith had a varying status in old Japan. At times officially sanctioned and encouraged, at others harshly banned, Christianity probably influenced the bushi caste more consistently than any other. There are examples in Japan's medieval military history of the benevolence of agape and of daimyo who put the welfare of their subjects ahead of their own, for reasons inexplicable other than out of pure altruism.

Whatever form it took, compassion, or *hodoku,* is written by the calligrapher with a character that originally meant "a billowing flag." The exact derivation is a matter of contention, with several theories put forth to explain how a banner fluttering could come to denote compassion. For the bugeisha who wishes to understand the historical concept of hodoko as practiced by the samurai, the kanji might call to mind the *nobori,* the tall, rectangular pennants that were mounted on poles worn at the warrior's back. Nobori identified the bushi's clan or unit, and flapping and billowing behind them, they were an important visual aid in battle for his comrades and his enemies. The banner was a symbol to the bushi of his station in life when he fought. It is entirely consonant with the values of the Way to see compassion as a kind of nobori running up the backbone of the bugeisha, a constant reminder of what is expected of him.

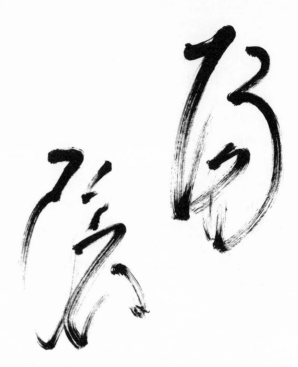

42 IN AND YO: DUALITIES OF THE WAY

陰
陽
The generative mythology of Shinto explains that in the beginning there was neither heaven nor earth, only a vaporous mass drifting in the cosmos. Set into spiral motion by a mysterious force at the moment of creation, essences were separated, the lighter rising centripetally to become the sky, the heavier rotating downward centrifugally to form the firmament. Into this new existence stepped the progenitor deities, Izanagi and Izanami, "She Who Invites" and "He Who Invites," from whom a whole pantheon of Shinto's divines were descended.

A heaven and earth created by corresponding motions and populated by a primordial pair of female and male. Such is the basic nature of the entire Shinto universe, a vast, intricately

complex connection of dualities, reverberations of which exert influences on the bugeisha and on his Way, whether or not he subscribes to this ancient faith. An interwoven duality of opposing and complementing principles, native Shinto ontology is a tradition that borrows heavily from Chinese Taoism. *In* and *yo* are Japanese pronunciations of yin and yang. The characters, respectively, represent the "lighted, south side of the mountain," and the "dark, north mountainside." The Japanese farmer, whose life depended upon his crop, was acutely sensitive to climate variations: the receptive warmth of the south sun, the cool darkness of slopes facing north. It is no surprise that he would perceive in his geographic surroundings a larger metaphor in the interplay of in and yo, a means by which his life and activities were regulated.

The bugeisha has a similar sensitivity to in and yo. His skills are an amalgam of hard and soft, quick and quiet, expansive and contractive, life and death. To neglect one component to focus exclusively on another is to disrupt the natural order of things, both within himself and in the world around him. Further, awareness of how in and yo interact brings the bugeisha to confront dualities of his own personality: his desire for comfort and pleasure versus the rigid demands of following a martial path, the desire for peace twined within the acquisition of brutal skills of violence. To discover these, to reconcile such apparent dichotomies is an important step in moving toward the destination of the Way, a journey itself so broad in scope that it embraces both the art of the sword and the art of the brush.